# JOHN HEDGECOE'S
# 35mm
# PHOTOGRAPHY

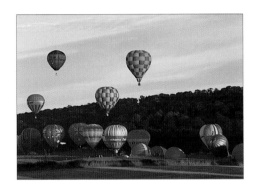

# JOHN HEDGECOE'S
# 35mm
# PHOTOGRAPHY

COLLINS & BROWN

First published in Great Britain in 1999 by
Collins & Brown Limited
London House
Great Eastern Wharf
Parkgate Road
London SW11 4NQ

Distributed in the United States and Canada by Sterling Publishing Co,
387 Park Avenue South, New York 10016, USA

Text: Chris George
Editorial Director: Sarah Hoggett
Editor: Katie Bent
Design Manager: Alison Lee
Designer: Amzie Viladout
Illustrator: David Ashby

1 3 5 7 9 8 6 4 2

British Library Cataloguing-in-Publication Data:
A catalogue record for this title is available from the British Library.

ISBN 1-85585-714-6

Reproduced by Classic Scan, Singapore
Printed by Dai Nippon, Hong Kong

# Contents

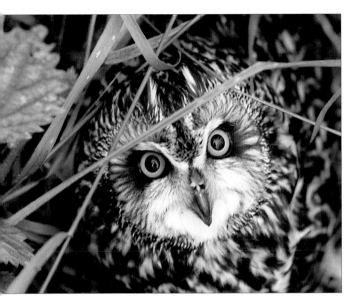

# Why do I need an SLR?

The beauty of single-lens reflex (SLR) cameras is the amount of control they give you over your pictures. They are system cameras, with optional extras, such as lenses, flashguns and filters, which allow the SLR to be adapted to a myriad of subjects.

The SLR also allows users to adjust shutter speed and aperture settings. These controls do not just adjust how much light reaches the film, they also allow the user to interpret a scene – so that it can be translated into a photograph that is far more than a mere snap or record shot.

**▼ Manual-focus SLR**
*Non-motorised SLRs give you all the advantages of SLR photography, and can be cheaper to buy than many point-and-shoot compacts.*

**Shutter speed dial** *for controlling exposure, reducing camera shake, and freezing or blurring movement.*

**Hotshoe** *socket for attaching a flashgun.*

**Viewfinder** *contains a five-sided prism that allows you to view the subject through the lens itself, so you know exactly how it is going to appear on film.*

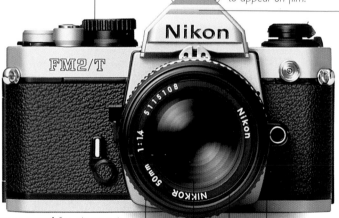

**Focus control** *for adjusting the lens and looking in the viewfinder to ensure the subject is sharp.*

**Aperture control** *allows you to blur distracting backgrounds or keep everything pin-sharp.*

**TTL metering** *ensures accurate exposure as the camera meters the light level through the lens itself.*

**Interchangeable lenses** *allow you to control how much of your subject appears in the frame.*

**▲ Choice of lenses**
The choice of wideangle, telephoto and close-up lenses means you can tackle any subject.

**▲ Freezing the action**
By using the appropriate shutter speed, fast-moving subjects can be caught on film.

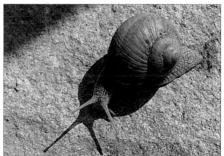

**▲ Sharpness control**
By using the right aperture, you can decide exactly how much of your picture is sharp.

**▲ Critical focus**
As you see exactly what you are shooting, SLRs allow you to frame close-ups accurately.

## The pros and cons of compact cameras

The portability and ease of use of point-and-shoot compact cameras make them more popular than SLRs, but they cannot deliver the same quality of picture.

| Advantages | Disadvantages | No-go subjects |
|---|---|---|
| Small – fits in pocket. | Built-in lens – longer or wider lenses cannot be added. | Most sports. |
| Simplicity – few buttons. | Rudimentary exposure and focus controls. | Most nature subjects. |
| Quiet and discreet to use. | Very little creative control. | Most creative photography. |

# When to choose autofocus

The first decision you have to make when buying a 35mm SLR camera is between autofocus (AF) or manual-focus models. In most conditions, autofocus is more accurate and faster than focusing manually – although you still have to ensure that the camera selects the right subject to focus on. You should also be aware of the situations when AF is not as effective – so that you know when to switch to the manual-focus mode, which is found on all good autofocus models.

▶ **Autofocus speed**
*Although all AF SLRs focus accurately on static subjects in good light, not all are as good with moving targets and low light. The best AF models can accurately tackle subjects moving at speed towards the camera, using a predictive auto-focus system.*

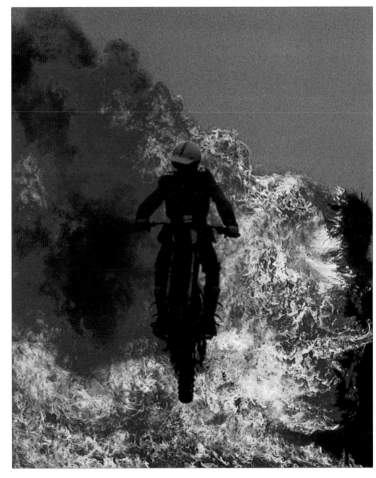

### ▶ Using the focus lock
*An AF system works on a small area in the centre of the image. If the subject is off-centre, you should focus on the subject in the centre of the viewfinder, engage the AF focus lock, and then recompose before firing.*

### ▼ Obscured view
*AF systems focus on the part of the picture nearest the camera within the sensor zone. If shooting through glass, the camera may focus on the glass, rather than on the subject beyond.*

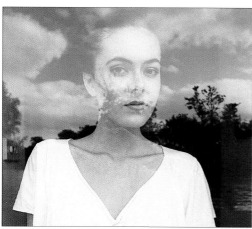

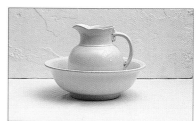

### ▲ Contrast detection
*Autofocus SLRs work on the principle that a sharp image is more contrasty than an out-of-focus one. Therefore, subjects with little contrast, such as this white jug and bowl on a white background, usually require switching to manual focus.*

## The pros and cons of autofocus cameras

| Advantages | Disadvantages |
| --- | --- |
| Easier to use and quicker than manual focus. | More expensive than manual models. |
| Can cope with fast-moving subjects. | Can struggle in low light and with low contrast. |
| Compensates well for failing eyesight. | Heavy drain on battery power. |

# Which sort of SLR?

Modern SLRs, particularly autofocus models, are packed full of labour-saving devices which are designed to make photography that much easier. As well as automating repetitive tasks, some of the features give you instant access to what used to be quite advanced techniques.

Not all features are found on all cameras, so you must decide which ones you want before you go shopping for your SLR.

▶ **Fill-in flash**
*Built-in flash units are not only useful in low light. In sunlight they can light up portraits (right) by filling-in and eliminating unwanted shadows (far right).*

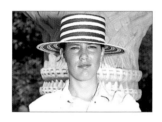

**Depth of field preview** *Some AF SLRs feature a depth of field preview that gives you a visual guide to how much of the subject is sharp, by closing down the aperture.*

**Pop-up flash** *A low-powered flash unit is useful for subjects that are a short distance away.*

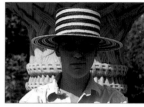

**AF assist** *A beam of light which can be shone onto the subject to aid autofocus in low light.*

▶ **Motorwind**
*Motorwinds not only advance the film automatically after each shot, but allow you to take a sequence of shots in rapid succession – useful for sport.*

## Auto-bracketing

The bracketing feature found on some SLRs allows a sequence of shots to be taken automatically, each at a slightly different exposure. Useful in tricky lighting conditions, or when using slide film (which needs much more precise exposure than print film).

A sequence of exposures helps ensure that one of them will be 'correct'.

**DX coding** *Most SLRs have a system that automatically sets the film speed (see pp. 34–35) whenever you change films.*

**Metering modes** *Some cameras give a choice of light meter system (see pp. 46–47 and pp. 50–51).*

**Exposure modes** *These control how the aperture and shutter speed are set. Program modes will control both automatically.*

**LCD panel** *This gives information on exposure, film and features currently in use.*

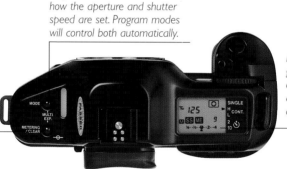

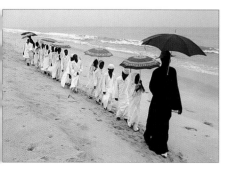

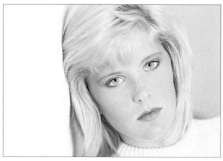

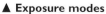
**▲ Exposure modes**
*Aperture priority mode is one of the ways in which you can set an aperture so that you ensure that all the wanted detail in your shot is sharp.*

**▲ Metering modes**
*Spot meters measure the light from a small area of the frame. They are useful for images with a very bright or very dark background.*

13

# What are f /numbers?

Aperture and shutter speed are the fundamental controls available to the SLR user. Varying one or other of these opens up a myriad of creative possibilities that are explored throughout this book. Both also control how much light reaches the film – so if you make the hole through which the light passes into the camera (the aperture) smaller, you must keep this hole open for longer (the shutter speed) to compensate. Fortunately, on most cameras this adjustment is made automatically. The size of the aperture is measured using f/numbers (or f/stops). Confusingly, as f/numbers represent fractions, the larger the f/number the smaller the aperture. The widest aperture on a lens might be f/2, whilst the smallest aperture available may be f/22.

## Relationship between aperture & shutter speed

This diagram shows that the same exposure can be achieved by adjusting the relationship between aperture and shutter speed.

Larger aperture

Smaller aperture

f/2    f/2.8    f/4    f/5.6    f/8    f/11    f/16

Faster shutter speed

$\frac{1}{1000}$   $\frac{1}{500}$   $\frac{1}{250}$   $\frac{1}{125}$   $\frac{1}{60}$   $\frac{1}{30}$   $\frac{1}{15}$

Slower shutter speed

Total amount of light reaching film (exposure) remains the same.

### ▶ Minimum aperture

In this shot I used an aperture of f/22 – the smallest opening available on my 100mm lens. As this lets in only a small amount of light, I had to keep the aperture open for longer than if I had used a wider opening. On this occasion a shutter speed of $1/30$ sec was needed so that the film received enough light to give correct exposure.

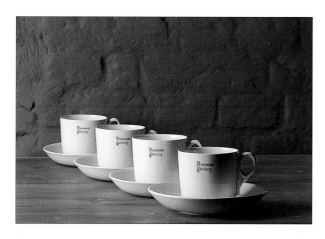

### ◀ Mid aperture

With each stop that the lens is opened, twice as much light is let in as the one before. Here I used an aperture of f/8 – three stops wider than the f/22 used above (the stops in between are f/16 and f/11). So the f/8 setting means eight times more light reaches the film than with the shot above. To get the same exposure, the shutter has to be open for just one-eighth of the time it was before – in this case, just $1/250$ sec.

### Maximum aperture

Opening the lens a further two stops to f/4 lets in four times more light. The shutter needs only to be open for a quarter of the time compared to the previous shot – so a shutter speed of $1/1000$ sec, the fastest on many cameras, was used. Notice how changing the aperture in the three shots has affected how many of the cups are in focus. This is known as depth of field (see pp. 28–31).

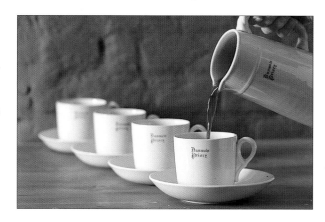

# Avoiding camera shake

Unless you are using a tripod, the first thing you should ensure when choosing the shutter speed is that it is fast enough to avoid camera shake. However tightly you hold your camera, it will always move slightly as you fire. If you use too slow a shutter speed this will mean blurred pictures. The speed you use depends on the focal length of lens you are using.

▼ **How to hold your camera**
*To be able to use the slowest possible handheld speeds, you must hold the camera correctly to avoid as much vibration as possible.*

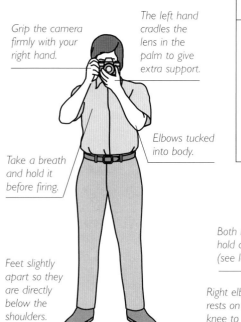

*Grip the camera firmly with your right hand.*

*The left hand cradles the lens in the palm to give extra support.*

*Take a breath and hold it before firing.*

*Elbows tucked into body.*

*Feet slightly apart so they are directly below the shoulders.*

### Minimum shutter speeds for handheld shots

| Focal length of lens used | Minimum shutter speed |
|---|---|
| 15mm | $\frac{1}{30}$ sec |
| 24mm | $\frac{1}{30}$ sec |
| 50mm | $\frac{1}{60}$ sec |
| 100mm | $\frac{1}{125}$ sec |
| 200mm | $\frac{1}{250}$ sec |
| 400mm | $\frac{1}{500}$ sec |

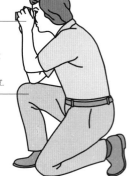

*Both hands hold camera (see left).*

*Right elbow rests on right knee to give extra support.*

▶ **Low-level shooting**
*You don't always want to take your pictures from normal eye level. This kneeling position allows you to take shots at waist level.*

**◄ 35mm lens – ¹/₃₀ sec**

*The easy way to work out the slowest shutter speed you can use when holding the camera by hand, is to divide one second by the focal length of lens you are using. Then round the answer down to the nearest shutter speed found on your camera. With a 35mm lens, a ¹/₃₀ sec shutter speed or faster should be used.*

**► 100mm lens – ¹/₁₂₅ sec**

*The longer the focal length of the lens you use, the more the image is magnified. Unfortunately, the effects of camera shake are also magnified – so a faster shutter speed is needed than with shorter lenses. With a zoom, you still will need a faster shutter speed at its telephoto settings than you will at wideangle ones.*

**◄ 300mm lens – ¹/₂₅₀ sec**

*Use more powerful telephotos still, and the shutter speed needed to keep the image sharp keeps going up. With a 300mm lens, the shutter speed you should theoretically use is ¹/₃₀₀ sec or faster – rounding the figure again, a ¹/₂₅₀ sec setting will suffice.*

# When to use slow shutter speeds

**B**y using a tripod, or other camera support, photographers can use slower shutter speeds than usual. These allow you to use apertures that would not otherwise be possible when using a handheld camera – and to shoot in the lowest light. Slow shutter speeds can also be used for creative effect, as moving subjects will become artistically blurred.

▶ **Maximizing sharpness**
*In this shot I needed to use the smallest aperture available (f/22 on my 35–70mm zoom) to ensure that as much of the picture as possible was sharp. This meant using a shutter speed of ¹⁄₁₅ sec – which if used handheld would not have been fast enough to avoid camera shake. I therefore used a tripod to hold the camera steady.*

## Using a tripod

• Tripods come in all sizes. Heavier models are more stable and can be used at a wide variety of heights.

• Smaller tripods are easier to carry.

• A centre column allows you to raise the height of the camera by small amounts using a crank.

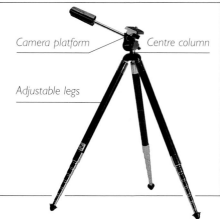

*Camera platform*   *Centre column*

*Adjustable legs*

### ▲ Nightscapes
With a solid tripod
exposures lasting
several seconds – or
even minutes – are
possible. This means
that you can shoot
pictures throughout the
night. For this cityscape
I used an exposure of
four seconds.

### ▶ Creative blur
The slower the shutter
speed, the more
blurred moving subjects
appear in the shot. This
technique adds the
appearance of
movement to an
otherwise still picture.
Here I used a ⅛ sec
shutter setting.

# When to use fast shutter speeds

**M**oving subjects require you to consider using a faster shutter speed than that needed to avoid camera shake. Some blur may be welcome with action subjects, but often we want to freeze the action. Selecting the right shutter speed depends not only on the velocity of the subject, but also on the direction in which it is travelling.

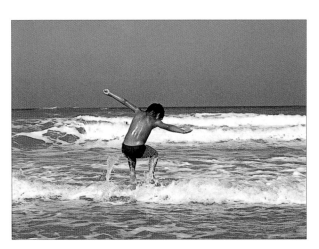

◀ **Frozen in mid-air**
*It is not just for sport pictures that you need fast shutter speeds. There is movement in practically everything we see – and sometimes this needs to be frozen crisply. In this shot the boy jumped on my command, and I was able to use a shutter speed of ¹/₁₀₀₀ sec.*

## Shutter speed guide

*The shutter speed you use depends on the subject and the direction that it is travelling in relation to the camera. The speeds given are the minimum needed to freeze the action and are for rough guidance only – the speed of one sprinter is different from another. The shutter speed also depends on how large the subject appears in the frame – the bigger it is the faster the shutter speed you will need.*

## Speed table

| Subject | Direction of movement | | |
|---|---|---|---|
| | Towards camera | Diagonal | Across frame |
| Pedestrian | ¹/₃₀ sec | ¹/₆₀ sec | ¹/₁₂₅ sec |
| Jogger | ¹/₆₀ sec | ¹/₁₂₅ sec | ¹/₂₅₀ sec |
| Sprinter | ¹/₂₅₀ sec | ¹/₅₀₀ sec | ¹/₁₀₀₀ sec |
| Cyclist | ¹/₁₂₅ sec | ¹/₂₅₀ sec | ¹/₅₀₀ sec |
| City traffic | ¹/₆₀ sec | ¹/₁₂₅ sec | ¹/₂₅₀ sec |
| Racing car | ¹/₅₀₀ sec | ¹/₁₀₀₀ sec | ¹/₂₀₀₀ sec |

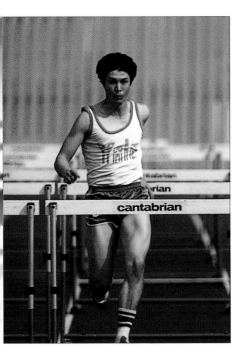

### ◀ Running towards the camera

*If a subject is heading towards the camera, you can get away with a much slower shutter speed than that needed if it is travelling across the frame. In the case of this hurdler, with the subject filling most of the frame, I used a shutter speed of ¹/₅₀₀ sec to be sure that the athlete was recorded sharply.*

### ▶ Galloping across the frame

*These racehorses moved extremely fast across the viewfinder, and the only hope I had of capturing them sharply was to use a ¹/₂₀₀₀ sec shutter speed.*

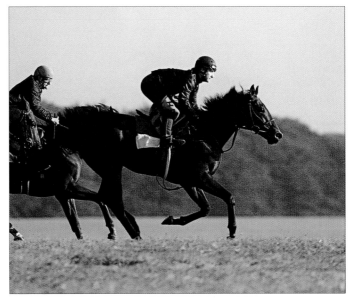

# What is 'focal length'?

Focal length is a measure of the light-bending power of a lens. It is invariably measured in millimetres (mm). The longer the focal length of a lens, the narrower the angle of view, and the larger objects appear in the viewfinder without the need to move any closer to them. Long focal length lenses are called telephotos – short focal lengths are called wideangles.

▶ **Wideangles**
*A lens with a focal length of 50mm is known as a standard lens – the view that it gives is similar to that of the human eye. Any lens with a shorter focal length, and wider angle of view, is known as a wideangle. This picture show the views afforded by common wideangle lenses.*

50mm

35mm

28mm

24mm

21mm

18mm

15mm

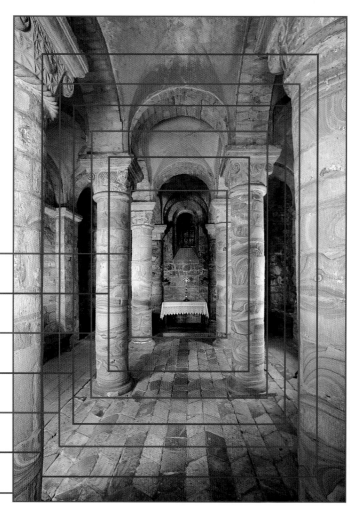

## How focal length affects image size

Lenses work on the principle that light reflecting from a subject can be bent using the refractive properties of glass to form a miniature image of the subject. Lenses with short focal lengths, such as the wideangle lens, produce a small image. Telephoto lenses, with longer focal lengths, produce a larger image, when taken from the same distance.

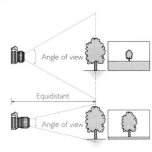

**Wideangle lens**
*A short focal length results in a smaller image.*

**Telephoto lens**
*Long focal lengths bring objects closer to fill the frame.*

▼ **Telephoto lenses**
*Telephotos are lenses with focal lengths greater than 50mm. They range from 70mm short telephotos to 'long toms' with focal lengths of 1000mm or more.*

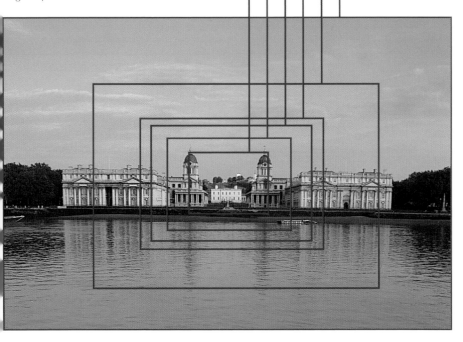

150mm   135mm
200mm   85mm
300mm   50mm

# Which lens should I use?

The wide variety of lenses that are available to the 35mm SLR owner can be bewildering. Lenses that offer just one focal length are called 'prime' lenses. The images shown here illustrate the type of photographs that you can take with wideangle and standard lenses. The following pages discuss telephoto and specialist lenses. Each has particular common uses, but most can be used in a variety of situations. Ideal focal lengths for the beginner are a 28mm wideangle, a 50mm standard, and 135mm and 300mm telephotos.

### ▼ 15mm lens

**Uses:** *For shooting interiors, or other confined spaces where an extreme angle of view is needed.*
**Characteristics:** *Such wideangle lenses provide a distorted view with noticeable bowing of straight lines, particularly towards the edges of the picture. The 15mm is only available as a prime lens.*

## Zoom lenses

An alternative to prime lenses are the zooms, which offer a variety of focal lengths in a single lens. The zoom is a cost-effective and lightweight alternative to carrying a bag of several different lenses. Popular zoom lenses include those with focal length ranges of 28–70mm and 70–200mm.

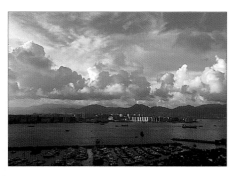

### ▲ 21mm lens
**Uses:** *Ideal for panoramas and also for interiors.*
**Characteristics:** *Such wideangle lenses offer tremendous depth of field, so everything from your feet to the horizon can be kept sharp easily. The 21mm gives some barrel distortion but not as marked as the 15mm lens.*

### ▲ 28mm lens
**Uses:** *An excellent all-round wideangle lens that is particularly well suited to landscapes and architectural photography.*
**Characteristics:** *Offers a good general view, including plenty of foreground and background. This focal length is found on a variety of zooms.*

### ▲ 50mm lens
**Uses:** *Suitable for all general photography.*
**Characteristics:** *The angle of view closely matches that of the human eye; foreground, middle ground and background bear the correct relationship to each other. 50mm prime lenses have wide apertures which can be useful in lowlight conditions.*

### ◄ 35mm lens
**Uses:** *Good for shooting portraits within an environment – such as people working. Ideal for reportage.*
**Characteristics:** *A good general-purpose lens, found on most point-and-shoot compact cameras.*

## ▲ Macro lens

**Uses:** Essential for close-ups, producing images which can be life-size on film.

**Characteristics:** True macro lenses come in prime focal lengths. Macro lenses offer a stepless range of magnifications and shooting distances. They are not restricted to close-ups: they make good portrait lenses, for instance. Some zooms offer a macro setting, although the image magnification is not as great.

## ▼ 135mm lens

**Uses:** Short telephotos are ideal for portraits as they don't distort facial features – unlike wider lenses – whilst still keeping close to your subject.

**Characteristics:** Consider shorter focal lengths (70–100mm) for full-length portraits, particularly when shooting indoors. A focal length featured on a wide variety of zooms.

## ◄ 200mm lens

**Uses:** Shortest focal length good for sport and wildlife. Good lens to use for candid portraits.

**Characteristics:** The longer the focal length you use, the harder it is to hold the camera steady without a support, so you are forced into using faster shutter speeds, and depth of field becomes increasingly limited. Focal length found on many telephoto zooms, as well as on 'all-in-one' zooms (such as the 28–200mm).

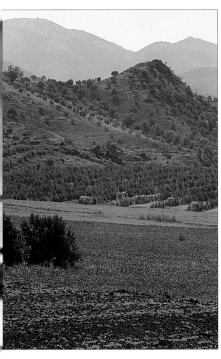

### ◀ 300mm lens

**Uses:** *The favourite focal length of sports photographers. Ideal for field sports such as soccer, rugby and American football. Similarly useful for many species of wildlife. Telephotos can be useful in all types of photography, however – even for landscapes, as this picture shows.*

**Characteristics:** *If you are considering buying a telephoto lens, it is well worth choosing one that includes this focal length. A 100–300mm is an excellent, readily available choice.*

### ▼ 500mm lens

**Uses:** *Good lens for small or timid wildlife, such as birds, also for sports such as cricket, baseball and motor racing.*

**Characteristics:** *Steady shooting is difficult without any form of support – a monopod (a more manouevrable alternative to a tripod) is therefore almost essential. Generally only available as a prime focal length. 'Preset' lenses, with fixed apertures, are excellent value for money. 'Mirror' lenses are lighter than traditional long telephoto designs. Depth of field is very limited, so accurate focusing is essential.*

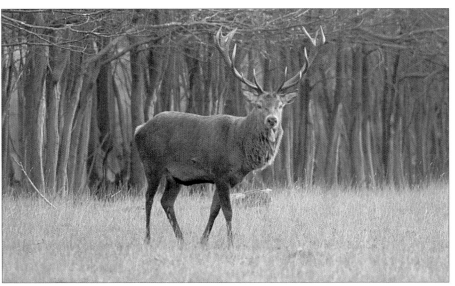

# Does focal length affect depth of field

Aperture is not the only factor that affects how much of a scene is in focus. You should also take into account the focal length of the lens being used and the distance that the lens is focused at (generally the distance from the camera to your subject). The longer the focal length,

the more restricted depth of field becomes. So, all things being equal, a wideangle lens keeps more of the scene in focus than a telephoto one. In addition, depth of field becomes increasingly more limited the closer you are to the subject that your lens is focused on.

## Factors affecting depth of field

These diagrams show how aperture, focused distance and focal length can individually affect how much of a scene is in focus. The shaded area indicates the amount of depth of field in front of, and behind, the subject.

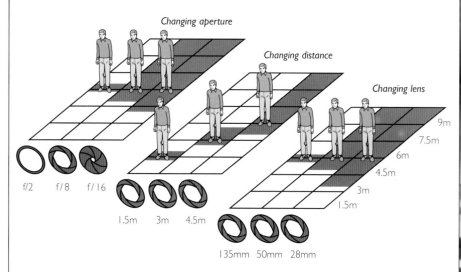

▲ **Aperture**
*The larger the aperture, the less depth of field. For maximum depth of field, use the smallest aperture.*

▲ **Focused distance**
*The closer the subject you focus on, the less depth of field. Depth of field is greater with distant subjects.*

▲ **Focal length**
*The longer the lens you use, the less depth of field you will have. Wideangle lenses give the greatest depth of field.*

### ▶ 28mm wideangle

*With a wideangle 28mm lens, the depth of field with an aperture of f/11 stretches from the buildings and gondolas a few metres or so away to as far as the eye can see. As a general rule, depth of field stretches twice as far behind a subject than it does in front of it. So to maximize depth of field in such shots it is worth focusing one third of the way into the scene.*

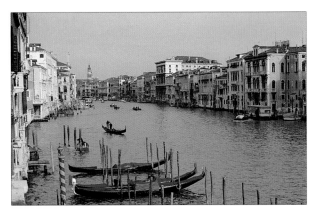

### ◀ 300mm telephoto

*Taken from the same viewpoint and with the same aperture as the shot above, the long 300mm telephoto setting provides less depth of field. Even though the range of distances is more limited (everything in the shot is at least 200m away), the furthest buildings are just out of focus.*

### ▲ Background just out of focus

*There are degrees to being out of focus. Here, a telephoto restricts focus so only the woman's face is sharp, but the wall behind is still recognizable.*

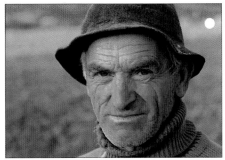

### ▲ Background very out of focus

*A telephoto lens again leaves the face sharp but the background, being further away, is not just out of focus, it is completely unrecognizable.*

# What is 'selective focusing'?

The aperture is not just used to control how much light enters the lens. It also regulates how much of the shot will be sharp.

Small apertures allow you to take shots where everything in the scene is sharp. Wider apertures let you restrict the amount of the picture that is in focus. Selective focusing is a powerful SLR technique that allows you to vary how much of the scene is in focus. Unwanted or distracting elements are made to look blurred by careful use of aperture.

A lens can only focus precisely on one plane at a time, but there is always some distance behind and in front of this plane that looks sharp to the human eye. It is this principle that provides depth of field.

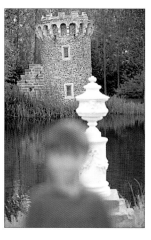

**▲ Background sharp**
*Focusing on the tower and using a 135mm telephoto with an aperture of f/2.8, the urn in the middle ground and the young boy in the foreground are thrown out of focus.*

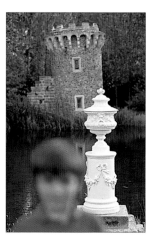

**▲ Middle ground sharp**
*Again a 135mm lens and a wide aperture of f/2.8. This time, however, the lens has been focused on the decorative urn. The eye is drawn straight to the point of focus.*

**▼ Foreground sharp**
*Here I focused on the young boy in the foreground, but have left the aperture of my 135mm lens at f/2.8. Note that the tower is more out of focus than the urn in the middle.*

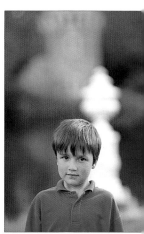

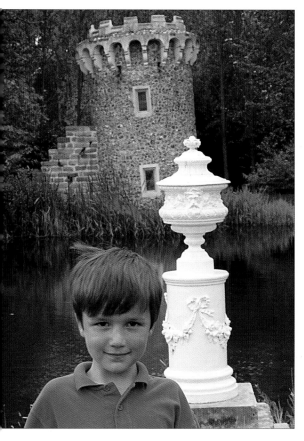

### ◄ Everything sharp

*In this shot I used the smallest aperture available to me to ensure that as much of the scene was in focus as possible. Again, I used a 135mm telephoto, but this time I used an f/22 aperture. To help maximize depth of field, I focused on the urn in the middle of the row. To ensure that everything you want to be in focus is actually sharp, it is worth using the depth of field scale on the lens, or depth preview (see box below).*

## How can you tell what's in focus?

**50mm lens**

The SLR's viewfinder shows you the amount of depth of field available with the widest aperture. For smaller apertures, some cameras have a depth of field preview, allowing you to see how much of the scene is sharp.

### Depth of field scale

*On some lenses, you can work out the exact depth of field at a given subject distance, using the focusing scale and pairs of marks corresponding to certain apertures.*

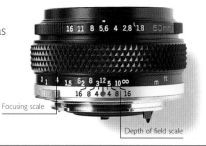

Focusing scale

Depth of field scale

# Does focus length alter perspective?

Perspective is affected by one factor alone – the distance of the subject from the camera. In theory, therefore, focal length does not alter perspective. However, because telephoto lenses are generally used to shoot subjects that are further away from the camera than wideangle ones, the choice of lens frequently changes the perspective of the scene.

Far wall looks distant

Room appears to get narrower

**▲ 28mm wideangle from 1 metre**
*With a 28mm wideangle lens, I shot this bust from just a metre away to get it to fill the height of the frame. Not only is much of the room included in the shot, but the perspective is typical of a wideangle lens, with the room appearing to narrow at the seemingly distant far wall.*

**► 150mm telephoto from 6 metres**
*Using a 150mm telephoto lens, I had to stand 6m away from the bust to get the same-size image as before. The only detail of the room left in the shot is the window at the far end. Typically for a telephoto lens, this appears much closer to the bust than in reality.*

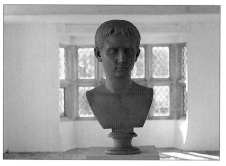

**▲ 50mm standard lens from 2 metres**
*Taken with a 50mm standard lens, this shot gives the most natural-looking perspective, matching that which a person in the room would see.*

**▲ 85mm telephoto from 3.5 metres**
*By using an 85mm telephoto lens setting, the side walls are no longer visible, giving less information about depth than with more wideangle lenses.*

*Pedestal looks squarer, less trapezoid*

*Far window now looks as if immediately behind statue*

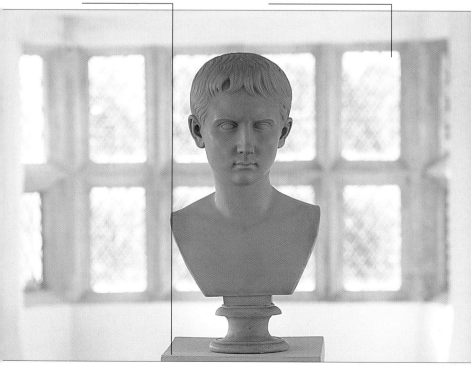

# Which film to use

Film is available in a variety of 'speeds'. The faster the film the more sensitive it is to light, and the shorter the exposure needed. Fast film produces a grainier image.

Film speed is measured on the ISO scale. A film rated at ISO 100 is four times slower than an ISO 400 film, and needs four times more light for the same shot.

**◄▲ Slow film and ultra-slow film**
*Slow films are not just used in sunny conditions. For the shot of the sculpture (left) I used a tripod and ISO 50 film. For the nightscape (above) I used ISO 100 film as I wanted a long shutter speed to blur the moving lights*

## Choosing the right speed of film

| Speed | ISO rating | Quality | Uses |
|---|---|---|---|
| Ultra-slow | ISO 25–50 | Very fine grain | Where fine detail is part of subject matter – ideal for still-life photography. |
| Slow | ISO 64–100 | Fine grain | For use in good light, or when slow shutter speed and tripod can be used. |
| Medium | ISO 125–200 | Medium grain | All-purpose film, providing compromise between grain and speed. |
| Fast | ISO 400–640 | Noticeable grain | For dull days, or when fast shutter speed is essential – such as with sport. |
| Super-fast | ISO 1000–3200 | Very noticeable grain | For handheld photography in low light – for indoor sport, for example. |

## Print film vs. slide film

| Slide (transparency/reversal) film | Print (negative) film |
|---|---|
| Requires very precise exposure. | Very tolerant of inaccurate exposure. |
| Film processed to make positive image. | Film processed to make negative image. |
| Slides can be made into prints, if necessary. | Negatives printed to make prints. |
| Printing stage is not necessary, so exposure and colour can be accurately controlled by the photographer, giving more predictable results. | Printing stage is interpretative, and usually out of the control of the photographer. Colour and exposure of print can be unpredictable. |

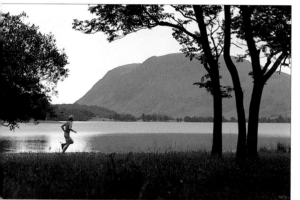

**◀ Fast film**

*Faster films, with a higher ISO rating, are needed in low light when faster shutter speeds are required, either to avoid camera shake or to freeze the action. In this shot, taken in fading sunlight, I needed a shutter speed of $\frac{1}{250}$ sec to freeze the jogger moving across the frame, and used ISO 400 film.*

**▶ Super-fast film**

*The fastest films are designed for handheld use in low light conditions when the fastest shutter speeds may be required. For this motorcycle race on an overcast day I needed shutter speeds of $\frac{1}{1000}$ sec or over to freeze the action, and chose to use ISO 1000 film. The grain on such films is noticeable particularly in shadow areas and at bigger enlargements – but this is far preferable to blurred photographs.*

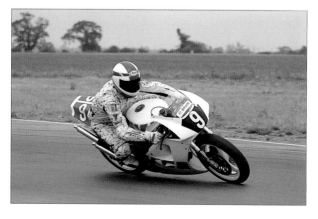

# When to use tungsten film

Although the human eye sees white paper as white, film sees it as a variety of colours depending on the lighting. With indoor, tungsten bulb lighting, for instance, subjects appear orange if shot with normal colour film. This is not a problem with print film, as the variation can be compensated for during printing. With slide film, however, remedial action must be taken at the time of shooting. Tungsten slide film is specially designed for use with bulb lighting – and particularly with the bright photoflood lamps used by some photographers – giving natural colours without additional filtration. Tungsten film is also optimized for use with long exposures (most daylight films are not).

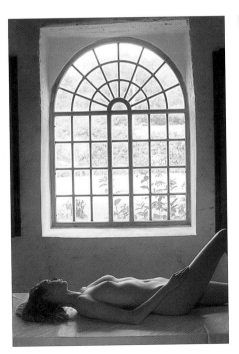

▲ **Tungsten film and daylight**
*With the model lit only by the ambient light from the window, the tungsten slide film has bathed the whole picture in a wash of blue. The effect is unnatural, but not unpleasant.*

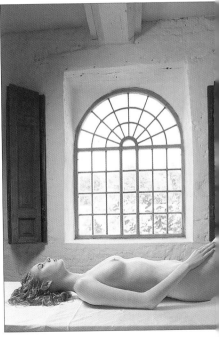

▲ **Tungsten film and tungsten lighting**
*In this shot tungsten photofloods have been used to light both the model and the room. The skin tones and white walls, therefore, appear in their correct colours; the outdoors still looks blue.*

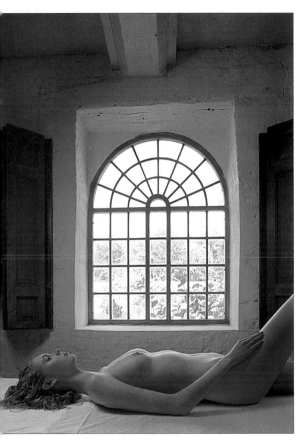

**◀ Tungsten film, daylight from window, and tungsten lighting on the model**

*In this shot, only the model in the foreground has been lit by the tungsten photofloods. The rest of the room is predominantly lit by indirect daylight. The mixture of lighting, therefore, gives the appearance of a background that has been given a blue wash – a rather pleasing effect, as the skin tones keep their natural colour.*

## Correcting for colour balance

• Household bulbs are more orange in colour than photofloods. With tungsten film, an 82A filter should be used on the lens when shooting using 150-watt bulbs, an 82B with 60-watt bulbs, and an 80D filter with 40-watt bulbs.

• You can use normal daylight slide film under tungsten photoflood bulbs, but you need to use an 80B filter.

• The colour balance, or temperature, is measured on the Kelvin (K) scale. Daylight film is optimized for use at 5500K, tungsten film for 3200K.

• Fluorescent strip lighting gives a greenish tinge to your photographs when using daylight film. This can be compensated for by using a purple filter, known as an FL-D.

# Using special films

Some films are specially made for scientific or business use, but for the adventurous photographer their peculiar properties can bring interesting results. Colour infrared film, for instance, was used by armed forces to detect camouflaged enemy sites – but can convert a normal landscape into strange colours. Black and white film, meanwhile, was once used by every photographer, but has now acquired a more specialist status Not only can it be used to suggest a bygone era, but can also be used to stress elements within a photograph other than colour (see pp. 124–125).

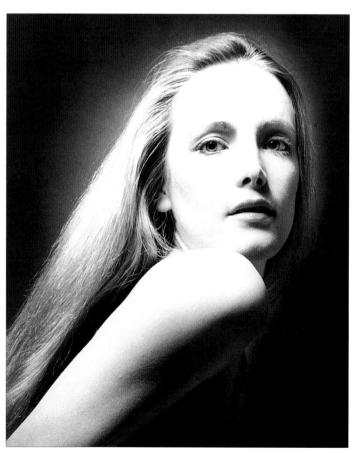

**◀ Black & white film**

*Black and white film suits a range of subjects, and is particularly useful fo portraits, as the lack of colour simplifies the picture without losing important information. The film also neatly avoids problems with different types of lighting, which otherwise create unwanted colour casts in a shot. Man amateurs use black and white film as it much easier to develop and print than colour material*

**◀ Black & white infrared film**
Infrared print film produces images with characteristic snowy-white foliage. For best results use a deep red filter. Infrared and visible light are focused at different planes by a lens, and as infrared light is invisible this causes problems when focusing. To help, a red manual-focus mark is found on many lenses, but the smallest aperture possible should still be used.

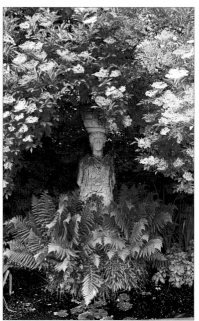

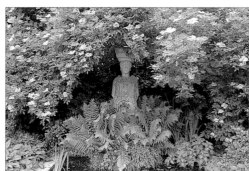

**◀▲ Colour infrared film**
Infrared slide film transforms the colour of things in strange ways (shot left – the same scene with normal film is shown above). Whites and blacks stay the same, but foliage turns purple, skies go cyan and red objects turn yellow. In portraits, skin looks waxy and the irises of people's eyes turn black. It is best used with a dark red filter. The lens is focused in the normal way, as some visible light is also recorded, but a small aperture is essential. The film needs to be stored in a freezer.

# Using filters & lens attachments

Filters have many purposes, from making subtle changes to the colours of your subject to adding breathtaking special effects. The most useful ones are often those where the addition of the filter to the front of the lens cannot be detected by the viewer – subtly improving reality. More extravagant filters should be used in moderation. Lens attachments are used in the same way as filters, but bend the path of the light rather than just absorbing some of its wavelengths.

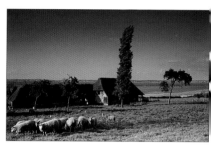

**▲ Graduated filter**
*Graduated filters darken or colour part of the picture without affecting the rest. They are useful for reducing the contrast between sky and foreground when shooting landscapes.*

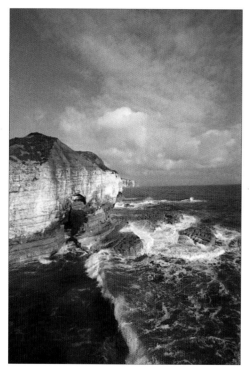

**▲ Skylight filter**
*Very useful at high altitude or by the sea, this filter helps eliminate the blue haze caused by ultraviolet light. As well as acting as a UV filter, the skylight filter is slightly amber-coloured, correcting for the blue colour cast still further.*

**▲ UV filter**
*The UV filter is similar to a skylight filter, except it is neutral in colour. It suppresses ultraviolet rays, and can be left on the lens at all times to protect against dust and scratches.*

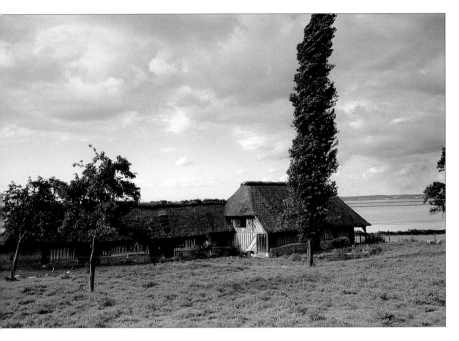

## ▲ Effect of aperture on graduated filters

You can increase the sharpness of graduation and the strength of colour by using a smaller aperture and a wider lens. The shot above was taken with a 35mm lens at f/16. That on the left, using the same filter and same viewpoint, was taken with a 50mm lens at an aperture of f/5.6.

## ▲ No filter

## ◀ Yellow filter

Filters with uniform colour are usually used with black and white film. But with backlit scenes they can add colour to a sky, and can even be used to give the impression of a sunset.

**▲ No lens attachment**
*Even with a small aperture, it is impossible to keep background and foreground sharp.*

**◄ Split-field attachment**
*Acting like bifocal glasses, this attachment has a close-up, magnifying lens over half the image, whilst the rest is clear. Objects that are very close to the lens are kept sharp in one part of the frame, whilst you focus on more distant subjects in the other half of the frame.*

**▲ Fisheye attachment**
*Fitting on the front of a standard lens, this add-on produces the same wideangle effect as a fisheye lens – but at a fraction of the cost.*

**▲ Polarizing filter**
*Polarizers cut reflections from water, helping you to see below the surface more clearly. Also used to deepen the colour of skies and shiny objects.*

► **Starburst attachment**
*Starburst, or cross-screen, attachments have a grid etched into clear glass. They are particularly useful for night scenes, turning highlights, such as street lights, into stars.*

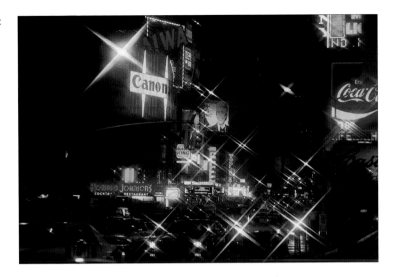

## Filters for black & white

Filters with a solid colour are particularly useful with monochrome as they can change the tonal balance, making objects of a particular colour appear as a darker or lighter tone in the picture. A green filter, for instance, will lighten foliage whilst darkening skies and deepening the tone of skin and lips in portrait subjects. The table below shows the effect of the most commonly-used filters for black and white.

▲ **Orange filter**
*Orange filters create moody landscapes, turning light cloud cover into a threatening storm. Red filters give a more pronounced effect.*

| Filter colour | Colours made lighter | Colours made darker |
| --- | --- | --- |
| Blue | Blue | Yellow, orange & red |
| Green | Green | Blue, orange & red |
| Yellow | Yellow, orange & red | Blue |
| Orange | Orange & red | Blue & green |
| Red | Red | Blue & green |

▲ **Yellow filter**
*A yellow filter creates natural-looking landscapes, restoring detail to clouds that is otherwise lost on film.*

# How to use flash

Flash is not only used to increase light levels, helping you to take pictures in the dark, it also changes the quality of the light in the scene. Without care, the change can be for the worse. Built-in flashguns found on many modern SLRs are useful, but the position of the unit means that the shadows it causes can detract from the picture, rather than adding to it. Backgrounds can also disappear, as any flashgun only has a very limited range and cannot light subjects at different distances evenly.

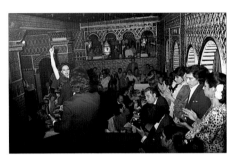

▲ **Inverse square law**
*The further the subject is from the flashgun, the less light it receives. If some areas of the frame are further away than others, these appear much darker, as in the shot above. The amount of fall-off is proportional to the square of distance.*

▲ **On-camera flash**
*Built-in flashguns, or those attached to the hotshoe, are convenient. Unfortunately, however, they produce flat lighting, with hard shadows that form an unsightly outline around one side of the subject, as seen in the shot above.*

## Banishing red-eye

'Red-eye' occurs when light from a flash reflects off the retina, illuminating blood vessels.

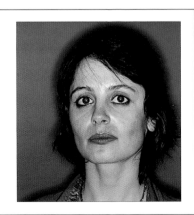

- Get closer to the subject and use a wider-angled lens if necessary. Move the flash away from the lens.

- Brighten room lighting to reduce the size of the subject's irises, so red-eye is less marked.

### ▶ Bounce flash

One way of improving the quality of the lighting from an on-camera flashgun is to use a unit with a tiltable head. This allows you to bounce the flash off a ceiling or wall. The bounced light is softer (see pp. 54–55), with less defined shadows. If there is no convenient surface to bounce off, a reflector unit can be fitted to the flash to produce a similar effect.

### ◀ Diffuse flash

To reduce the harsh light of an on-camera flash unit you can fit a diffuser over the flash. This disperses the light, creating a softer effect. It is particularly useful for flash shots of close-ups and other subjects where a mass of heavy shadows would be undesirable.

### ▶ Off-camera flash

The best way to fit a flashgun to an SLR is with a bracket. This brings the unit well away from the lens, reducing red-eye and producing a more modelled lighting. The flash head can then be bounced or diffused as desired. The remote flash unit is then connected to the hotshoe or the SLR's flash socket using a lead. Here, off-camera flash has been used to provide fill-in on a sunny day, producing a side-lit appearance.

# Using built-in meters

All modern 35mm SLRs have built-in meters that measure the amount of light being reflected off a subject. Your exact composition, and the lens you are using, are taken into account as the meter reading is taken through the lens. Depending on the exposure mode, the meter can then set the shutter speed or aperture, or both, automatically.

On occasions, however, the built-in meter gets the exposure 'wrong' and fails to give the result you want. Bear in mind that there is not always a 'correct' exposure. In high-contrast situations, in particular, it is not possible for film to provide detail in the shadows without actually losing detail in the brightest areas. A compromise has to be made – and the camera may not make the same choice as you. Through practice you will be able to identify these situations and take remedial action.

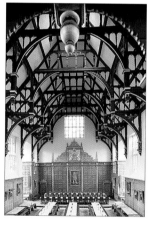

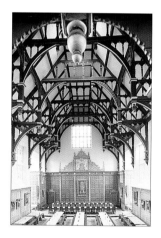

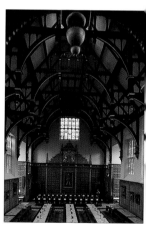

▲ **'Correct' exposure**
*This gives the best exposure of the three shots – allowing us to see just enough detail in the roof and the tables. In tricky lighting conditions, it is a good idea to shoot a series of shots at different exposures – to ensure that you get the result you want. This technique is known as bracketing (see p.13).*

▲ **Over-exposed**
*Correct exposure is often a compromise. This shot has been exposed correctly for the shadows – but too much of the rest of the frame is now too bright and over-exposed.*

▲ **Under-exposed**
*This shot gives the best exposure for the window. But the real subject of the picture is the interior of the hall, and this appears much too dark.*

### ◀ Centre-weighted average metering

*The way in which the exposure meter works varies from camera to camera — and some even have several metering systems to choose from. One of the commonest types is centre-weighted metering. This takes an average reading from across the whole frame, but biases it to the central area, where the subject is normally found.*

### ◀ Matrix metering

*Matrix, or evaluative metering, found on more recent SLRs, takes readings from a number of 'zones' within the frame. It compares these readings with data stored in the camera to work out the type of picture that is being taken, picking an exposure to suit. It is more accurate than centre-weighted metering — but it is harder for the user to predict when the camera will get it 'wrong'.*

## Overriding the built-in meter

Although the manual exposure mode lets you set aperture and shutter independently of the meter, an easier way to adjust exposure is to use the SLR's compensation facility (right). This allows you to change the exposure value by a number of stops. Each extra stop represents a doubling in exposure, whilst one less stop halves exposure. You can also darken or lighten the image by changing the ISO speed setting.

# When to use over-exposure

The photographer most often has to give more exposure than the camera suggests when shooting a subject against a bright background. If the light area fills much of the frame it misleads the meter, and in the resulting exposure the subject appears too dark. Backlit subjects and white backdrops usually demand that you give the frame more exposure.

▶ **Snow scenes**
*Snow always presents a problem to camera meters, as the vast areas of white reflect any existing light. If a normal meter reading is used, the snow appears a muddy grey, and the rest of the photograph is under-exposed. By over-exposing the shot by between one and two stops, the snow becomes burnt out and looks its natural white.*

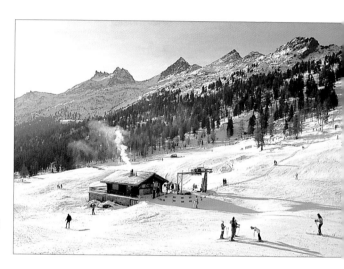

◀ **Over-exposing for effect**
*Over-exposing pictures can give them a ghostly, ethereal appearance which can work well with some subjects. In blazing sun an over-exposed shot can convey the blinding heat better than a normally exposed one. In this shot, I over-exposed by two stops to make the colours of the watery landscape appear more muted.*

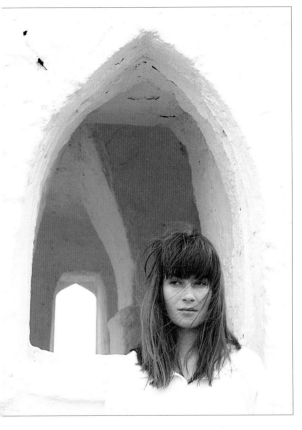

**◀ Exposing for the skin**

*In portraits, it is more important to get the exposure right for the face than for anything else in the picture. In this predominantly white scene, the bright background is bound to confuse the camera's built-in meter. I gave the shot another one-and-a-half stops to ensure that the skin tones looked right. It is worth noting that accurate exposure is less important with colour print film than it is with slides. Colour negative film can be under-exposed by a full stop and over-exposed by four stops – and you still can get a printable result. With slide film, exposure only allows half a stop latitude either way.*

## Incident light meters

Handheld meters may be used to avoid the problems of built-in exposure systems. A pocket meter allows you to measure the amount of light falling on a subject – as well as that being reflected off it. This extra 'incident' reading can be particularly useful as it is not affected by the colour or the reflective properties of the subject or background.

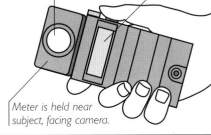

*Removable diffuser is put over sensor for taking incident readings.*

*Read-out gives aperture and shutter speed to be used.*

*Meter is held near subject, facing camera.*

# When to use under-exposure

Under-exposure is often needed when you want to sacrifice detail in the shadows to ensure that the brightest areas look right. A good example is a silhouette – it doesn't matter how dark the subject is, but the background should be correctly exposed. Under-exposure can also be used subtly to boost the richness of colours in a photograph.

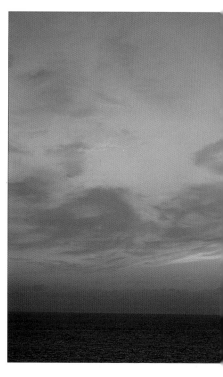

**◄ Creating a dramatic sky**
*In many pictures you must sacrifice colour in the sky to ensure the subject is well-exposed. In this shot of a white-timbered New England church, it did not matter if the white timbers appeared slightly grey, as this is more than compensated for by the intense blue of the sky. I under-exposed the shot by one stop to achieve this.*

**► Sunset splendour**
*Built-in matrix and centre-weighted exposure meters tend to bias exposure towards what is at the bottom of the frame – so that they are not distracted by large expanses of sky. When shooting sunsets, however, it is the sky itself that is the main subject. To get the full richness of reds and oranges you may need to under-expose the shot by around one stop.*

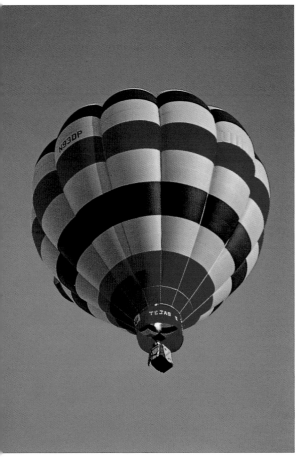

### ◀ Unusual conditions

*When shooting flying objects against the sky – whether planes, birds or hot-air balloons – it is generally necessary to over-expose slightly to allow for the brighter sky. With the sun directly behind me, and framing tightly around the balloon, however, the subject and the background were of equal brightness. I therefore under-exposed by a third of a stop to saturate the red stripe and the blue of the sky.*

### ▼ Natural beauty

*When shooting close-ups of flowers I invariably find that I need to under-expose by half a stop – otherwise the colours of the blooms are paler than they seem in real life.*

## Using a spot meter

• Many SLRs have built-in spot meters that can take an exposure reading from a small area within the frame.

• They help avoid problems with bright and dark backgrounds, allowing you to meter from a midtone in the subject.

# Direction of light

**B**right, sunny days do not guarantee great pictures. It is the quality of light that is more important than the quantity. The angle of light dictates where a subject's shadows fall. Although not obvious to the untrained eye, it is shadows that give vital details about depth, texture and three-dimensional shape. Without this information, pictures can look lifeless. The direction of light also plays a major role in whether the colours in your pictures look rich and appealing or pale and washed out.

## Using light in portraits

Shadows on a face can accentuate its shape, especially on features like the eyes, nose and mouth. Use light and shadow to flatter the sitter.

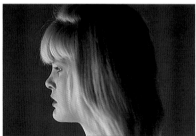

▲ **Facing the light**
*Gives richest colour to the face, but produces heavy shadow around the nose and eyes.*

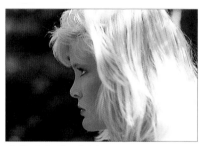

▲ **Back to the light**
*The face is in semi-shadow, lit by reflected light. This gives a soft, flattering appearance.*

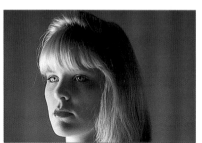

▲ **At an angle to the light**
*Half of the face is in light, the other half in semi-shadow. This gives a good 3-D effect.*

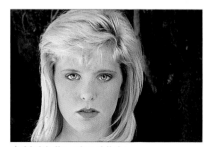

▲ **Multi-directional light**
*Facing the light, but a reflector fills in shadows under features. A good compromise.*

### ▲ Sidelighting

With the sun to the side of the photographer and the subject, some parts of the picture are in light and others in shadow. This gives good colour in the lit areas, whilst the shadows provide information about depth and form, known as modelling.

### ◄ Frontal lighting

If the sun is behind the photographer, colours are recorded at their richest. The lack of shadows means that buildings facing the sun look two-dimensional, but because of the even lighting and lack of contrast, accurate exposures are easy.

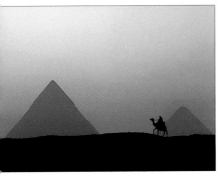

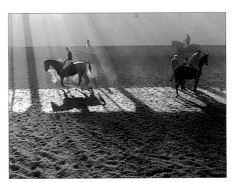

### ▲ Backlighting

With the sun in front of the photographer, the subject is bathed in shadow. If we expose for the sky, as in this shot, we end up with a silhouette. There is no detail about subject colour, texture or form – all that is left are the shapes.

### ▲ Rim lighting

This is essentially backlighting, but in this special situation the edges of the subject just catch the sun, creating a bright halo around the dark subject. The effect works best if the sun is just out of the frame and the background is also dark.

# Hard & soft light

In direct sunlight, shadows cast by a subject are distinct. This is known as hard lighting. However, light is not always direct. Sometimes it is diffused by clouds, sometimes it is reflected off buildings, the ground or even the sky itself. This indirect illumination is called soft lighting as it produces very little shadow, hitting the subject from many different directions.

▶ **Hard light**
*Direct sunlight produces distinct shadows around the features of the face. It produces a livelier, less two-dimensional picture, but the shadows can often hide important detail and may not always be flattering.*

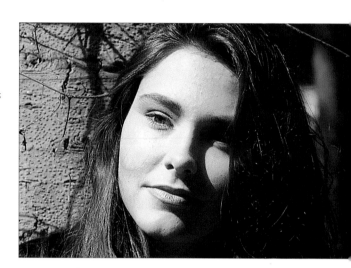

◀ **Soft light**
*An overcast day produces portraits with less distinct shadows – allowing you to see the whole face. The indirect light makes the skin look softer and the nose and eye sockets appear less chiselled and angular. This can sometimes be more pleasing than using direct lighting.*

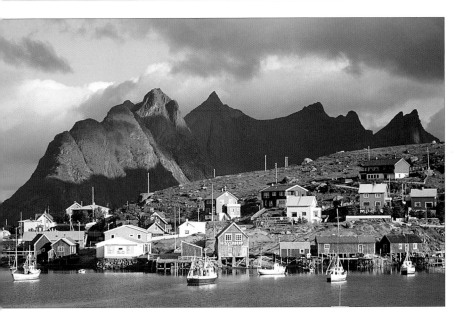

### ▲ Direct sunlight
With unobscured sunlight, colours look their strongest. Distinct shadows on the sides of buildings, which are only partially lit by soft light, help to give a feeling of depth and three-dimensional structure.

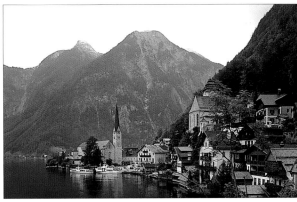

### Diffuse sunlight
Soft light, diffused by clouds, produces more pastel colours. In complex scenes, the lack of distinct shadows can help to simplify the composition.

## How clouds affect light

Clouds act as giant diffusers, scattering sunlight in thousands of different directions. The heavier the cloud cover, the softer and more diffuse the light is.

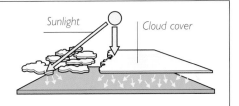

Sunlight | Cloud cover

# Simple studio set-ups

One or two studio lights will enable you to control indoor lighting for portraits and still lifes. Flash units are more usual, but older-style tungsten lamps are still available.

The brightness of both can be changed not only by adjusting the power of each light individually, but also by using diffracting and reflecting attachments to soften the effect.

▶ **Typical portrait lighting set-up**
*The main light is placed at 45 degrees to the side of the subject, slightly above the height of the model's head. The fill-in light is bounced into a brolly attachment, to make it less powerful than the main light and is positioned the other side of the camera, again at 45 degrees to the line between the subject and camera.*

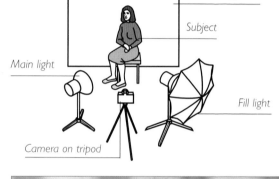

Background
Subject
Main light
Fill light
Camera on tripod

▶ **Main light only**
*The main light should be set up first and positioned above the subject, so that the shadows are similar to those cast by the sun. It provides good modelling to the face when positioned to the side of the camera.*

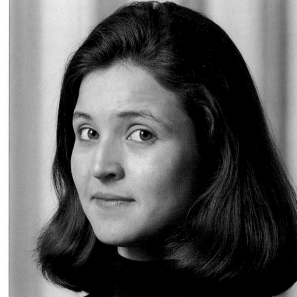

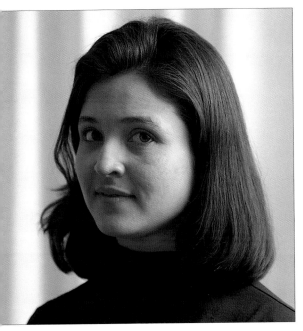

### ◀ Fill light

The purpose of the fill light is to soften the shadows cast by the main light. It should therefore be positioned to the opposite side of the subject. Its power should be set to around a half or a quarter of that of the main light. Alternatively, a reflector, or white board, can be used to add fill-in.

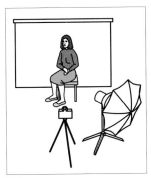

### ▶ Fill & main lights

With both studio flash units in place, the shadows on the face of the subject are softened. Just enough shadow (or modelling) is provided by the more powerful main light to suggest three-dimensional form.

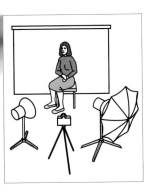

# Selective framing

The most fundamental part of composition is choosing what, and what not, to include in the frame. By changing camera position and focal length, you can mask off unwanted subject matter and concentrate on certain elements. Checking the viewfinder carefully and exploring all the angles are important skills for the photographer.

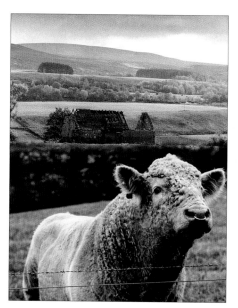

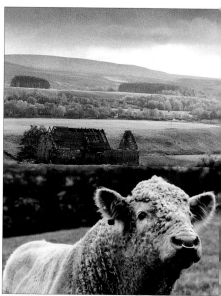

**▲▶ What to include**
*The viewer need never know what was outside the frame of your picture. In this scene I chose to include the cow, barbed-wire fence, and the landscape beyond (above). But I could have chosen to crop out the fence from the shot (above right), or to ignore the foreground entirely and home in on the landscape itself, using the tumbledown barn as the foreground for my shot (right).*

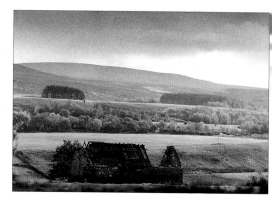

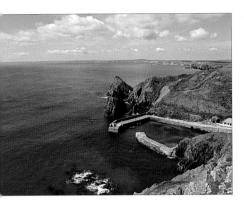

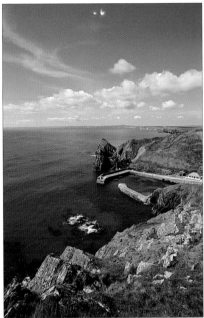

**▲ Horizontal framing**
*SLRs allow you two different image proportions, depending on how you hold the camera. The horizontal (landscape) format works for most subjects.*

**▶ Vertical framing**
*The vertical (or portrait) format can be used for any subject where the upright shape suits the subject better. Often both the horizontal and vertical formats will work equally well.*

## Changing camera height

As well as changing camera angle, subject distance and lens, the photographer should try to explore different shooting heights. These can not only affect how the subject looks, but change the background too.

**▲ Shot from elevated camera position**
*Looking down on children exaggerates their small size; here, it has simplified the background.*

**▲ Shot from low-level position**
*Kneeling down gives a more natural-looking shot; here, the background is more cluttered.*

# Dynamic balance

Once you have decided what to include in your picture, you can fine-tune the composition by altering where the subject appears in the frame. It is generally best not to place the main point of interest of your photograph right in the middle of your frame. Moving the emphasis of your picture away from this central point creates a more dynamic picture. How far you move the subject towards one of the four sides is open to debate, although many photographers follow the 'rule of thirds' (see below). Always bear in mind that rules can be broken.

▶ **Using extremes**

*The closer you place the focal point of your picture to the edges of the picture, the more radical your composition becomes. In portraits, it is the sitter's eyes that form the main focal point — the viewer is drawn to them automatically. Placing the eyes well away from the centre of the frame in this shot created a particularly dynamic study.*

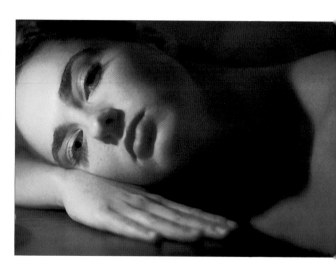

## Rule of thirds

The 'rule of thirds', used by artists and photographers, states that if you were to place a grid over the viewfinder to form nine equal rectangles, the best position for your subject would be at an intersection or along a line (either vertical or horizontal).

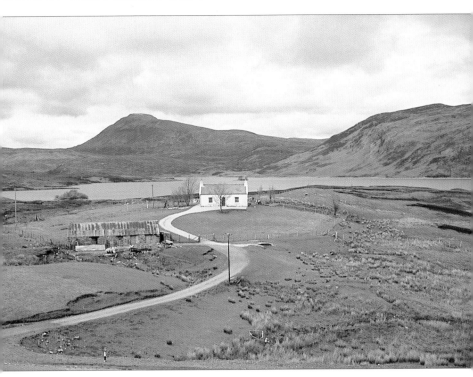

## ▲ Placing the horizon

With landscape shots, the position of the horizon within the frame is critical. To avoid a symmetrical shot, include approximatley two-thirds land and one-third sky. However, with a sky that is interesting in its own right, such as a dramatic sunset, you might choose to include only one-third land (see pp. 96–97).

## ► Symmetry

In some pictures you can stress the symmetry in the subject by breaking the rules and using a symmetrical composition, where the subject falls in the centre of the frame. In this shot I deliberately placed the skyline halfway up the frame, to emphasize the near-perfect reflection of the Taj Mahal in the water. The resulting shot is balanced and elegant.

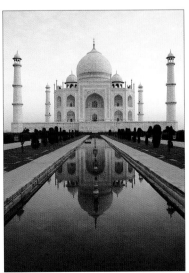

# Diagonal emphasis

When framing a shot, even the simplest changes can have dramatic effects. One way of escaping from a series of tame record shots is to avoid having straight lines that run parallel to the edges of the picture. Diagonal lines running across the frame look more dynamic. The best effect is when the lines run at 45 degrees to the sides.

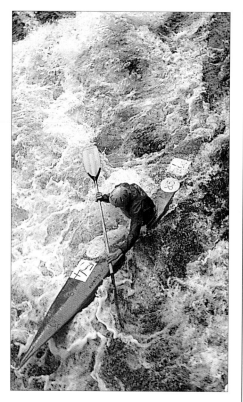

**▲ Adding a sense of movement**
*A subject placed diagonally within the frame is more likely to look as if it is moving. As canoeists constantly change direction as they negotiate the currents and the course, it was a matter of waiting until the canoe was at 45 degrees across the viewfinder before pressing the shutter.*

## Changing viewpoint

Moving closer to a subject, and using a wider lens, can often turn uninteresting parallel lines into diagonal ones.

**▲ Distant view**
*Shot from 30 metres away with a 50mm lens, the vertical lines of this bizarre Austrian church run parallel to the edge of the picture frame.*

**▲ Low-angle close-up**
*Standing directly by the church, and pointing upwards with a 28mm lens, the vertical lines now run diagonally across the picture frame.*

### Dynamic diagonals

this candid portrait, there are
several strong diagonal lines
that add tension to an
otherwise stationary scene. First,
there is the line of the wall,
which helps lead the eye
through the frame. Then there is
the angle of the boy's pipe. The
strongest line, however, is that of
the other boy's leg, as he leans
against the wall.

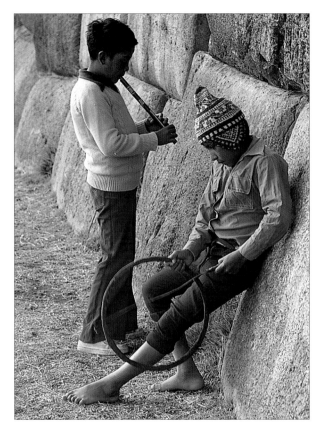

### ◀ On the tilt

Even when there are no natural
diagonal lines to exploit, you can
always inject them by angling
the camera. In this shot I
twisted the camera slightly to
capture this chimpanzee so
that its body and eyes create
diagonal lines running through
the frame. It is a technique that
movie makers call the 'Dutch
tilt' – and as with all such tricks,
it should not be over-used.

# Lead-in lines

**B**y careful framing, natural lines, such as roads and rivers, can be used as a compositional device to draw the viewer to the main subject within a picture – providing a path for the eyes to follow. A strong diagonal from left to right leads the eye into the picture, from foreground to background. Look for lines that break the edge of the frame.

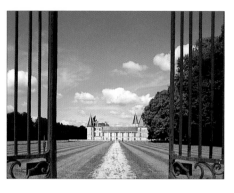

**▲ Path to subject**
*The light-coloured driveway in this picture immediately grabs the viewer's attention, leading the eyes to the French château in the distance.*

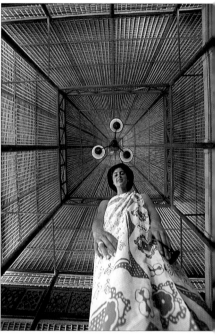

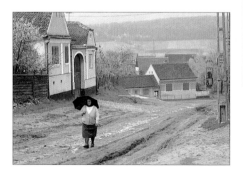

**▲ Path from subject**
*In this shot, the woman in the foreground is the main focal point of the picture. But the strong diagonal line of the rough road then leads us to explore the rest of the composition.*

**▲ Radiant lines**
*The intersection of the lines of this elaborate roof make a strong focal point. I deliberately framed the portrait, using a low-angle camera position and wideangle lens to include the lines, and so the figure of the woman became another line leading to the central point.*

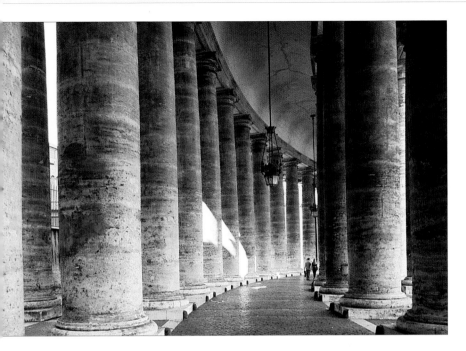

## ▲ Curves

Curved lines form a more gentle way of leading the viewer through a picture than straight lines. However, they are more difficult to engineer through composition and camera angle. This sweep of columns provides a ready-made sense of recession where they turn away from view.

## ▶ S-bends

Curved lines that bend this way and that are known as S-bends. In landscape shots, they can readily be found where rivers or roads weave across the countryside. In this shot the S-shape of the river is mirrored in the line of the tree trunk in the foreground.

# The power of colour

Some colours attract the eye more than others – drawing a strong emotional response from the viewer. Reds, in particular, tend to leap out of a photograph – especially when they are surrounded by more muted shades. The strength of colour, however, is dependent on the lighting being strongest when the sun is direct and behind the photographer.

▲ **Powerful combinations**
*Signs, clothing and cars offer a wide range of strong colours for the photographer. In this close-up study, the combination of the two complementary colours, purple and yellow, makes for a dynamic shot.*

▲ **Bright contrasts**
*Bright colours draw the eye, especially when surrounded by duller tones. This shot is made by the fiery field of yellow rape in the foreground. Frontal lighting will tend to strengthen colours, especially when it is not diffused.*

## Complementary colours

The colour wheel is useful for showing how different colours go together. The three primary colours – red, yellow and blue – are complemented by the secondary colours – orange, green and violet. Directly opposite each primary is its complementary colour. The most striking colour contrast is when a primary and its complementary are seen together (yellow with violet, red with green, or blue with orange).

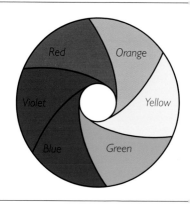

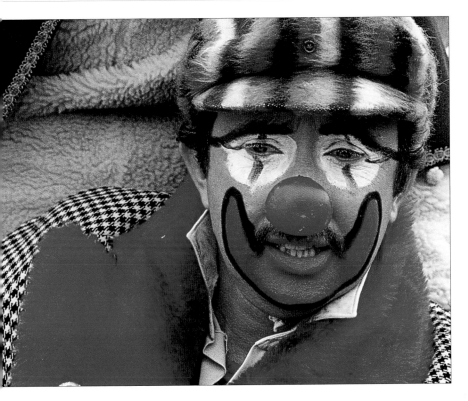

## ▲ Scarlet fever

*Red is the most powerful colour in the photographer's palette. It draws the eye into the photograph and can convert an otherwise mundane shot into an interesting one.*

## ▶ Warm and cool contrast

*Reds tend to assert themselves in pictures: they are a warm colour and appear to advance towards the viewer. Blues, on the other hand, are cooler and tend to recede into the picture. Combining the two not only creates contrast, it also adds depth.*

# Pattern

Repetition and pattern can be found in practically everything we see – whether it is the way bricks are arranged in a wall, or how bottles are placed on a shop shelf. But because they are so commonplace, we rarely notice them. By focusing in on the pattern alone, you can produce fascinating pictures that challenge the way we look at the world.

▶ **Random pattern**
*Not all patterns are symmetrical. On this unusual building the doors, stairs and windows seem to have been placed haphazardly onto the white walls. The bright colours attract the eye into trying to make sense of the design.*

◀ **Repetitive pattern**
*Many man-made patterns are so obvious that we do not notice them. Here I have used a telephoto lens and an angled camera position to highlight the repetitive shape of the roofs along these terraced houses.*

### ▲ Natural pattern

Nature yields many of the best patterns – from the spider's web to a crocodile's scaly skin. To be able to isolate such patterns, you frequently need a macro lens to be able to get in close enough.

### ▶ Ordered pattern

Backlit against an evening sky, the shape of each of these silhouetted trees appears near identical. The orderly planting is stressed by the head-on camera position.

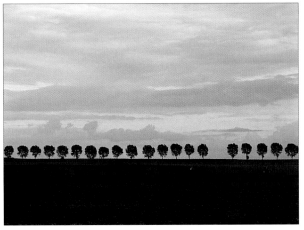

ESSENTIAL SUBJECTS

# Portraits

Care and attention must be paid to lighting and lens choice when shooting pictures of people. Use a wideangle lens for a close-up, and the perspective will mean that the size of the sitter's nose will be exaggerated. A short telephoto lens is ideal.

Direct lighting, too, can provide unflattering results. Few people want to be shown with deep shadows under their eyes. Soft lighting usually works best.

There are times, as ever, when breaking these rules can bring effective results.

## Suggested kit

✔ ISO 100 film, so that grain does not mar skin tones.

✔ Lens with 100mm focal length. A 70–200mm zoom is ideal.

✔ 35mm wideangle lens, to show the setting in a portrait.

✔ Flashgun on bracket for fill-in, and/or a reflector.

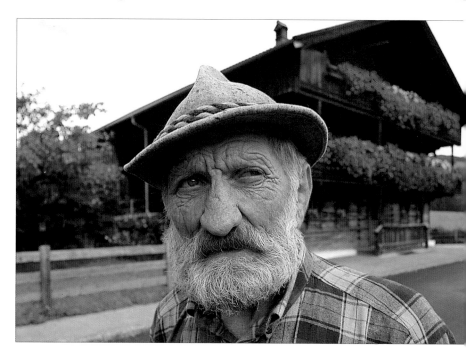

▲ **Wideangle approach**
*Using a wideangle lens for a portrait may not flatter the subject, but it does allow you to show more of his or her surroundings.*

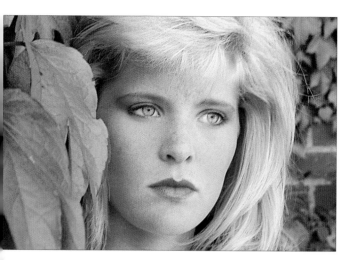

**◄ Soft lighting**
*Indirect light – for example on a bright yet overcast day – is particularly flattering for portraits. There are no unsightly shadows under the eyes and nose to contend with. For this shot I used a 100mm lens.*

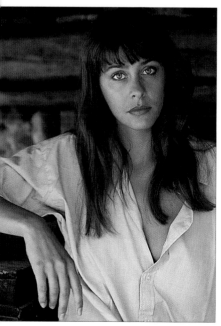

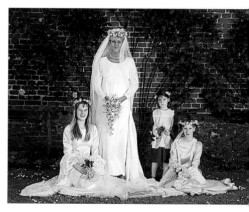

**▲ Fill-in flash**
*Flash can be particularly useful for portraits – even in daylight. It can help lift the colours in subjects' clothes, and adds attractive reflections, known as catchlights, in their eyes. This wedding group was taken with a 70mm lens.*

**▲ Using a reflector**
*When using direct sunlight, a reflector will lighten the shadows on the darker side of the face. A piece of white card makes an effective reflector.*

# Children & babies

Children are not only the most popular photographic subject the world over, the arrival of a baby in the family often spurs people into taking pictures seriously for the first time or after a break of many years.

There is much truth in the Hollywood saying that you should never work with children or animals. Photographing kids can be rewarding – but it is also hard work. Whilst you can cajole adults into suitable poses, and keep them waiting as you get organized, children lose patience fast – and co-operation is rare.

Not only must you be prepared, so that you can work fast, but you should also have a supply of things that will distract their attention away from the camera – a favourite toy or pet, for example. As they play, you will be able to shoot candid shots that will invariably look more natural than any posed portrait.

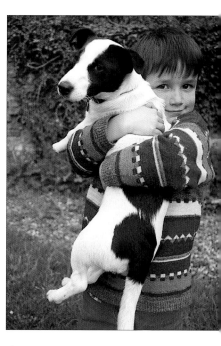

**▲ A faithful companion**
*Children can be more co-operative if you let them decide how they should pose for their picture. This boy didn't want his dog to miss out on the portrait session – and I was only too happy to oblige.*

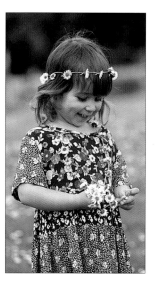

**◄ Busy hands**
*Giving children something interesting to do will keep them occupied as you shoot. Making daisy chains kept this girl busy for ages.*

## Suggested kit

✔ *Fast film (ISO 400). Children don't keep still, and fast shutter speeds are essential.*

✔ *Telephoto zoom (70–200mm), so that you can shoot candid portraits unobtrusively.*

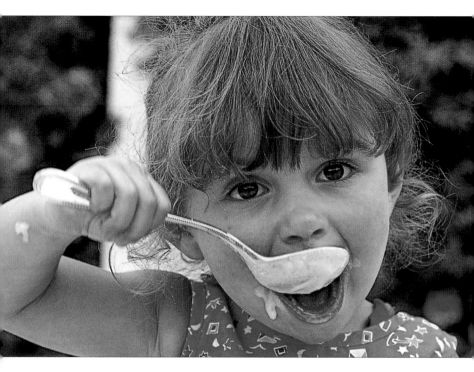

## ▲ Get down to their level

Portraits of kids look better if you kneel or crouch down so that the lens is at their eye level. If you stand upright, the pictures literally and figuratively appear as if you are looking down on them.

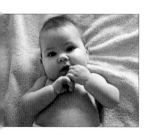

### ▲ Let babies lie

Babies cannot sit unaided. For a natural pose, lie them on a blanket and shoot from above, using light from a window.

### ▶ Wide view

Less-tightly framed shots add scale, showing just how small the subject really is against the backdrop of nature.

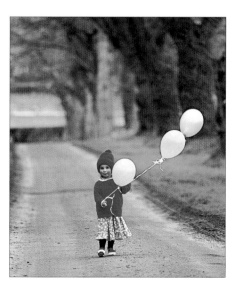

# Sport

The sort of lens you need for sport depends on just how close you can safely get to the action. A 200mm lens will sometimes do, but generally a 300mm or longer is needed for good shots.

A fast shutter speed is not only needed to freeze the subject, it is also essential to get the wide aperture settings that will ensure that distracting backgrounds are thrown completely out of focus. Choosing your film speed carefully will allow you to get the right combination (see speed table on p. 20).

Picking the right moment to shoot, and finding a good vantage point, depends greatly on how well you know a particular sport. Rather than practising at a professional game, where you will be jostling with thousands of other spectators, it is better to try a local park. Amateur games let you get closer, and give you a wider choice of camera position; the pictures can be just as good.

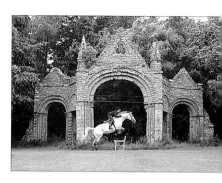

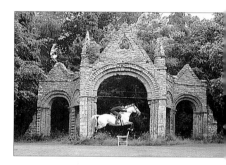

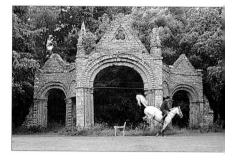

**▲ Motordrive sequences**

*Many cameras have built-in motorwinds that allow you to take a sequence of shots in rapid succession. This will not guarantee capturing that vital moment, but it can help. The number of frames shot each second depends on the camera*

## Suggested kit

✔ *Fast film: use ISO 400 in reasonable light and ISO 1600–3200 in low light.*

✔ *A 300mm lens, with a wide aperture, is good all round.*

✔ *Longer lenses, such as a 500mm, are needed for sports like baseball.*

✔ *Monopod to keep the camera steady yet mobile.*

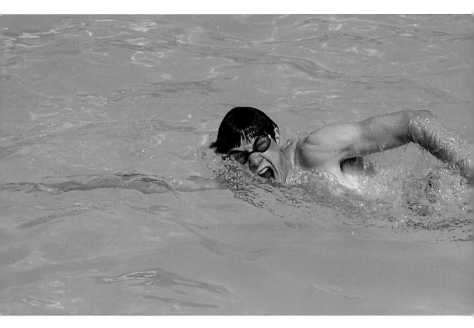

### Freezing the action

r pin-sharp images you will need to choose a
utter speed that is fast enough. For this shot I
eeded a 200mm lens and a speed of ¹/₅₀₀ sec.

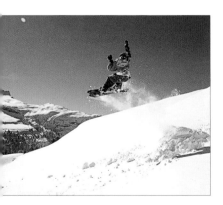

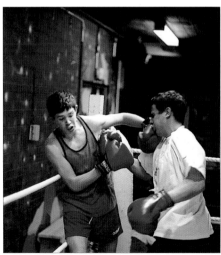

### Pre-focusing on a point

/ith action there is little time to focus. Prepare
 focusing on a spot you know your subject will
oss, and then shoot when they enter the frame.

### ▲ Fast film catches the moment

Use a faster film for action shots than you would
with other subjects in similar lighting. Here I used
an ISO 640 high-speed film.

# Nature

The techniques and equipment that you need to photograph the natural world vary depending on the size of the creature and on its timidity.

The smallest, such as insects, require special close-up equipment, such as a macro lens, and small apertures. Small, shy animals, such as most birds, require long telephotos and a discreet vantage point, such as that offered by a hide.

Larger, or tamer, animals need no specialist equipment, but patience is still required to get a suitable pose. Family pets, zoos and bird gardens offer photographers the chance to master the basic skills before heading into the wild.

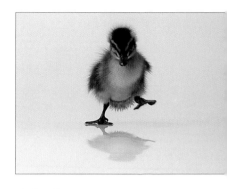

**▲ Studio set-ups**
*Some animals and insects can be brought indoors, allowing you to have complete control over the background and the lighting.*

**◄ Use a long telephoto lens**
*Without a hide, a 300mm or 500mm lens is necessary to get close-up pictures of wild birds.*

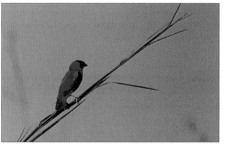

**▼ Tame animals**
*Farm animals are used to humans being around. This allows you to get close to your subjects, so long lenses are not necessary. I crouched down and took this shot with a 100mm lens.*

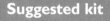

## Suggested kit

✔ *ISO 200 or 400 film.*

✔ *Long telephoto lens, such as a 100–300mm zoom.*

✔ *90mm or 100mm macro lens, or use extension tubes which fit between a normal lens and the camera body.*

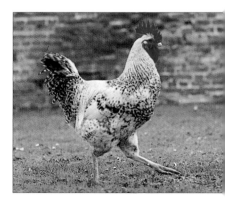

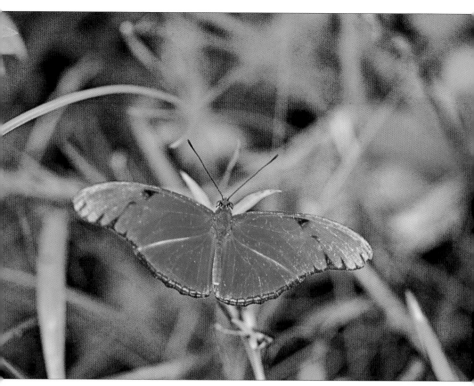

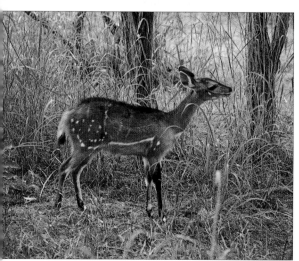

### ▲ Close-up technique
*Full-frame shots of insects require using a macro lens or extension tubes. Depth of field is severely limited, so very small apertures are essential. You will also find that it is easier to focus the lens precisely by moving the camera to and from the subject until it appears sharp in the viewfinder.*

### ◄ Wild animals
*You can get very close to some wild animals if you move towards them very slowly and stay downwind. I shot this study of a deer with a 200mm lens.*

# Landscapes

As mountains and fields do not move, landscapes may seem like one of the simplest subjects to tackle – giving you all the time in the world to get it right. However, although the lie of the land may not change, the colours of the vegetation alter with the season, and the clouds and light can change with the minute.

Landscape photography, therefore, is a waiting game requiring much patience. Professionals will wait for hours until the light is right, or keep returning to a spot for the conditions to be perfect.

The best results generally come at the start or end of the day, when climatic conditions are changing most.

Although the wideangle is the hallmark of the landscape photographer, longer lenses are also essential for homing in on details, such as a solitary tree in the middle of a ploughed field.

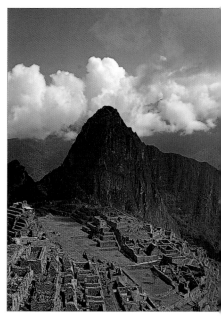

▲ **Avoiding haze at altitude**
*Haze is caused by millions of dust particles in the air. The best way to avoid it is to shoot straight after rain, as this washes the sky clean.*

## Suggested kit

✔ Good wideangle lens or a zoom with a 28mm setting.

✔ Telephoto lens for details – a 100–300mm zoom would be perfect.

✔ Solid tripod that can with- stand rough terrain and strong winds. Gives you a free choice of aperture.

✔ Filters, such as a graduated blue or grey, polarizer and skylight (see pp. 40–43).

▲ **Grey days**
*You don't always need sunlight to shoot landscapes. There is beauty in the way in which clouds and colours change in poor weather.*

### ▲ Patterns in nature
used a short telephoto lens to accentuate the
stripes of colour, caused by the rows of olive trees
and the poppies growing wild in between.

### ▲ Breaking sunlight
Passing clouds can produce a patchwork of light
over fields. Wait for the right moment, then shoot.

### ▶ Aerial perspective
Mist adds tone to distant objects – this can
create a feeling of depth and recession in a shot.

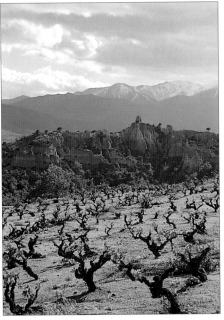

# Gardens

Although gardens are delightful on hot summer days, this is not usually the best time to photograph them. Strong, but diffused light is best, as it avoids the delicate shapes of plants being swamped in strong shadows.

Practically any type of lens can be used. Wideangles allow you to include grand vistas and buildings, whilst telephotos let you pick out individual plants. For shots of smaller blooms a macro lens is necessary. Strong winds, however, can make close-ups impractical.

Stately homes and parks are planted to provide interest through the seasons – allowing you the opportunity to take pictures at any time of the year.

## Suggested kit

✔ 35–70mm and 70–200mm zooms to allow for wideangle and close-up shots.

✔ 90mm or 100mm macro lens for individual blooms.

✔ Portable reflector, for fill-in and to serve as a windbreak when shooting flowers in a breeze.

**▲ Spring**
*Including buildings in your shots shows the context of a garden, and here provides a scale for this sea of yellow daffodils.*

**▲ Summer**
*Most gardens look their best in the summer months. Direct sunlight shows off the colours well, but beware that shadows can obscure detail. Under-exposing shots on slide film by around half a stop can help to boost colour saturation.*

**▶ Winter**
*Even on the coldest days, there can be interesting shots to be found. Here, hoar-frost has transformed this evergreen climber, forming an icy-white pattern.*

## ▲ Formal symmetry

With formal gardens, stress the symmetry of the design with your composition. Here I have framed the shot so the right-hand side is a mirror image of the left – just as the gardener intended.

## ▼ Simple shapes

Simple patterns are found all over the garden and can be extracted with a well-aimed zoom.

## ▲ Close-ups on an overcast day

Close-ups of flower heads are best taken under cloud cover, when shadows do not interfere with the beauty of blooms. A macro lens and a tripod are useful here, allowing you to get in really close and keep everything sharp.

# Architecture

Trying to fit a whole building or room into a single frame can cause particular problems for the architectural photographer. Wideangle lenses can come to the rescue here, but there are often other solutions worth·exploring.

Sometimes you can shoot from further away – from the other side of the road, perhaps. In many situations, you can end up with a more rewarding shot by just concentrating your lens on part of a picture and zooming in on details that a passer-by would not normally notice.

## Suggested kit

✔ Slow-speed film (ISO 100), for maximum detail.

✔ Lens with 28mm wideangle setting or wider. 21–35mm zoom would be ideal.

✔ Telephoto lens (70–200mm) for distant shots and details.

✔ Tripod for interior shots that need small apertures.

## Shift lenses

Shift lenses avoid the problem of the sides of tall buildings seeming to converge as you shoot them from ground level. The lens is moved upwards on the camera to get the top in without tilting the camera.

▶ **Normal 28mm lens**
*Tilting the camera upwards when shooting buildings means that parallel lines appear to converge. This is because the film is not parallel with the face of the building.*

▶ **28mm shift (or PC) lens**
*Without tilting the camera, a shift lens enables the photographer to include the top of the church – by racking the lens itself upwards. The result is that the vertical lines of the church no longer slant towards each other.*

## ▲ Super-wideangles for interiors

Use the widest lenses available when space is severely restricted. Here I used a 21mm lens.

## ► Distant views

Shooting tall buildings from a distance gets round the problem of converging verticals. I used a 70mm lens so I could include the beautiful setting of this mountain church. A x2 extension lens could also be helpful.

## ▲ Look out for patterns

I used a 100mm lens to frame up the zigzag patterns on the roof of this cathedral.

# Still life

A still life is a picture in which inanimate objects are arranged and shot for their own sake. For any photographer it can be an invaluable way to learn about lighting and composition.

Almost any portable object will work as a subject, but it is the way in which you arrange the shot that makes or breaks the picture. The surface on which to put the object and the background should be chosen first. Then the subjects are arranged and suitable props are added. The dedicated still-life photographer collects pieces of weathered wood, old stone slabs, interesting plates and so on, to help dress future compositions. Always check the composition through the viewfinder, as small changes in the angle of view can make a huge difference.

The right type of lighting is crucial. Generally strong, directional lighting works best, with fill-in from the unlit side. This can be provided by studio lights, but window light can be just as effective.

## Suggested kit

- ✔ ISO 100 film or slower.

- ✔ Macro lens or extension tubes.

- ✔ Tripod to hold camera as set-up changes are made.

- ✔ One or two studio flash units with 'soft-box' diffusers to provide even lighting.

- ✔ Large reflector to provide fill-in.

▲▲ **Choosing backgrounds and props**
*These boots (above) make an interesting composition themselves. Adding flowerpots (top) sets the scene. Find backgrounds and surfaces for your arrangement that complement, rather than distract from, your composition.*

### ▲ ▼ Varying the composition

As you have complete control, still-life pictures allow you to endlessly move objects around and change camera position in search of new shots.

### ▼ Matching colours

For shots with several subjects, you can simplify the scene by using objects from the same colour family.

# Night

Whit the photographer should load
up with fast film or switch on the
flashgun. In reality, many outdoor pictures
taken after the sun begins to set are best
shot with a slower film.

For pictures of fireworks, cityscapes and
fairgrounds, for instance, slow shutter
speeds (and a tripod) allow you to
capture moving lights as picturesque
streaks. The longer the exposure the
better the effect, so slow film will help.

Although night shots can be taken at
any time after dark, you often get the
best results just after sunset, when there
is still some colour in the sky and it is
not yet pitch black. Also, excessive
contrast between light and shade is
avoided, so that films can cope better
and accurate exposures become easier
to calculate.

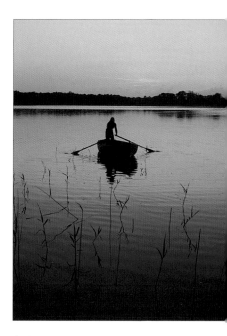

**▲ Sunset silhouette**
*Sunsets can look good on their own, but can be
improved by including something in the foreground
which is still identifiable as a backlit silhouette.*

**▼ Low-light portraits**
*Modern super-fast films allow you to shoot hand-
held portraits even in the lowest lighting
conditions. Here I used an ISO 1000 slide film.*

## Suggested kit

✔ Slow film (ISO 100) and a
tripod for long-exposure shots.

✔ High-speed film for handheld
shots (ISO 1000–3200).

✔ Low-cost 50mm standard
lens has a wider maximum
aperture than a zoom – hand-
held shutter speeds can be
four times as long.

✔ Cable release or self-timer to
cut camera vibrations with
slow shutter speeds.

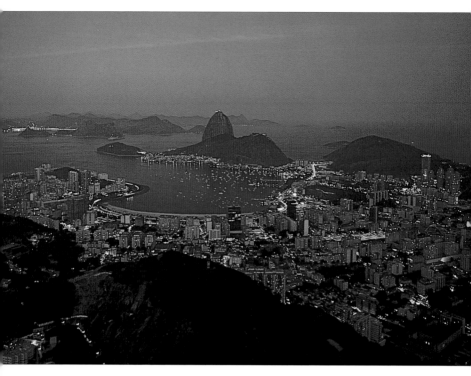

## ▲ Bulb exposure

In order to record car lights as streaks, you need to use a shutter speed of 10 seconds or longer. You may have to use the B (or bulb) setting of the camera, which keeps the shutter open for as long as the release trigger is held down.

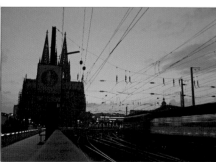

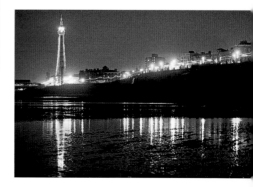

## ▲ The twilight zone

If you shoot just after sunset, colourful city lights can be shown against a sky that is not jet black.

## ▶ Foreground reflections

A stretch of water, even a puddle, allows you to double the number of lights in your shot.

DEVELOPING YOUR SKILLS

# Studying shape

There are four main elements that enable us to recognize the things around us – shape, texture, form and colour. Photographers can exploit these elements, mainly through lighting. Shape is the most economical of these elements. Shot from the right angle, it is possible to identify most objects through shape alone. Even people, if we know them well, can be identified from a silhouette, without seeing the colour of their skin, hair or eyes. With strong backlighting, the object or person is bathed in shadow, giving no information about hue, texture or three-dimensional form. Other ways to experiment with emphasizing the shape of a subject include using contrasting background and under-exposure.

**▲ Plain white backdrop**
*In the studio, the outline of a subject's pose can be accentuated by using a plain background. White paper, bought in rolls, works best.*

**▼ Angled backlight**
*With a combination of back- and sidelighting, this scene shows up the the intricate network of the tree's branches, as well as the shape of the distant hills. The leaves, however, remain well lit.*

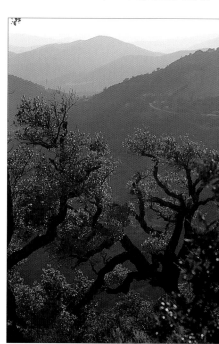

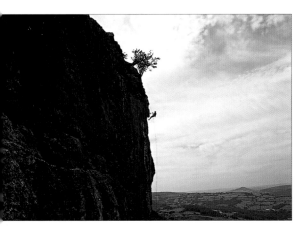

**◀ Classic silhouette**
*Even with just the shape to go by, there is no mistaking that this is a picture of an abseiling rock climber. With the subject backlit, all I needed to do here was take a meter reading from the sky, lock the exposure, and recompose the shot.*

**▼ Monotone mood**
*Early-morning mist creates low-contrast images, with no detail or colour. Only subjects with strong shapes, shot at the correct angle, will work here.*

**▼ Deliberate under-exposure**
*I darkened this shot by under-exposing it by one-and-a-half stops. This has thrown the figures into shadow, emphasizing their profiles at the expense of seeing their faces.*

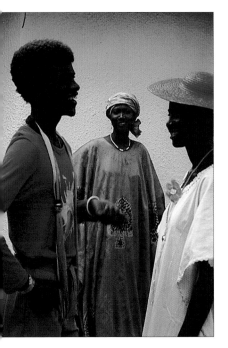

## Technical tips

• Avoid detailed backgrounds when emphasizing shape – a simple one, such as a sky, works best.

• When shooting silhouettes, expose for the background, not the subject. Use your camera's exposure lock.

• Avoid looking at the sun directly through your camera.

# Emphasizing form & texture

Form is the three-dimensional shape of objects. Photographs are two-dimensional, and give little information about depth. It is the shadows on the surface of an object that give us clues to reveal form. Sidelighting can be used to produce a mixture of shadows and highlights. Objects that are backlit or front-lit appear flatter. Angled lighting can also be used to reveal texture as it catches raised areas to create shadows. Beware of this effect in portraits – it may accentuate wrinkles.

**▲ Gradations of light and shade**

*To produce the shadows that are needed to reveal the form in pictures, you need to use sidelighting. The shadows should not be too hard, however, as they may become a uniform black. Soft sidelighting is needed to provide a range of tones, as in this shot, or fill-in could be used to lighten the shadows.*

## Technical tips

• Use a reflector to soften shadows when using direct light to reveal form.

• Use a lens hood to avoid flare.

### ► Overhead light

Toplighting is not necessary to reveal texture – all the lighting must do is to strike the surface at a sharp enough angle. In this photograph the midday sun is almost directly above. As it rakes across the upright surface of these panels, it reveals every grain line and hole on the well-weathered wood.

### ▲ Sidelight skimming the surface

In this shot the sun is to the right of the camera, creating strong stripes of dark and light green that reveal the ribbed texture of the foliage.

### ▲ Zooming in on texture

Peeling paint and rust may not seem great subjects. But isolated and lit from above, they make a colourful pattern reminiscent of abstract art.

# Placing the horizon

The classic way to compose a landscape is so that the sky fills the top one-third of the frame, and the land fills the other two-thirds. But not all shots need be like this. Experiment with placing the horizon in a different part of the frame – straight through the middle of the frame, at the bottom, or even leaving the horizon out of the shot completely. The position of the horizon affects the mood of the picture and can be used to create more dynamic images. Centrally placed horizons create static images, but the symmetry suits some shots.

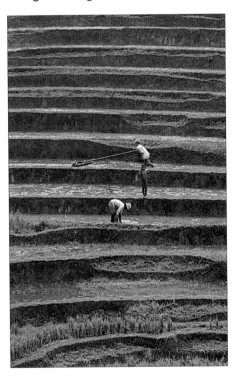

▲ **Low horizon**
*Placing the skyline towards the bottom of the frame creates a sense of space and openness in your compositions. It is also a useful trick to employ when you want the sky itself to become the focus of attention in your picture.*

▲ **No skyline**
*Leaving out the horizon allows you to concentrate on patterns, shapes and colour in a landscape. The technique can also help when you have a dull, featureless sky – or when the relative brightness of the sky causes exposure problems.*

## Technical tips

• Wherever you place the horizon, make sure that it is straight. Scrutinize the viewfinder carefully to see that the horizon runs parallel with the bottom of the frame.

• To help you avoid distracting, sloping skylines, a miniature spirit level can be bought which slots into the hotshoe of your camera.

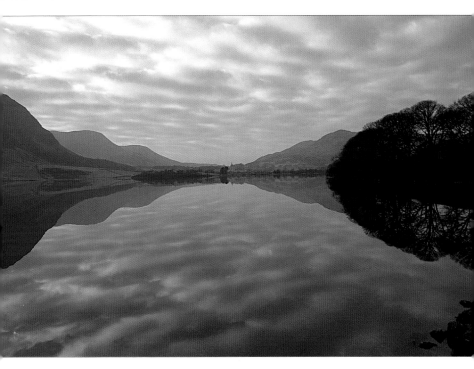

## ▲ Central skylines

*In most situations, photographers avoid placing the horizon so that it divides the frame evenly in two. The resulting image can look static and lifeless, and a better shot results by placing the skyline higher or lower in the frame. In this shot, however, the compositional technique accentuates the perfect symmetry created by the reflection in the lake, and helps to convey the feeling of tranquillity.*

## ▶ High horizons

*The safest way to compose a landscape is so that the sky occupies, at most, only a third of the frame. This ensures the horizon is off-centre, which immediately creates a dynamic composition obeying the rules that have been passed down to photographers by the great painters. It also means that the camera's built-in meter will not be unduly influenced by the brightness of the sky.*

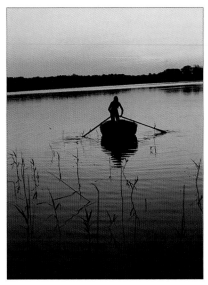

# Filling the foreground

Although we most frequently use wideangle lenses to shoot landscapes, the use of these lenses can cause compositional problems. The angle of view and distant perspective tend to emphasize the foreground of the picture. Often this area is a dull, featureless expanse of earth or grass. The challenge is to find objects that are already there that will usefully fill this space – without the new subject matter detracting from the landscape beyond. The secret is to find a natural foreground that can be incorporated just by altering your camera position.

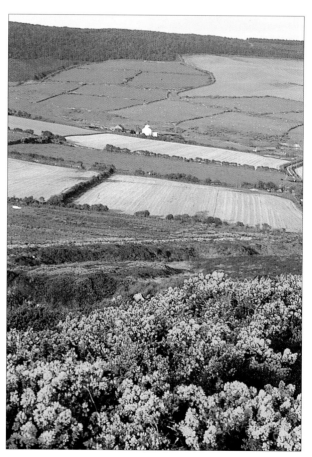

**◀ Splash of colour**
*The foreground of this view from a hillside has been filled by choosing a camera angle that included these brightly-coloured bushes. The yellow foreground draws the eye into the picture and adds interest.*

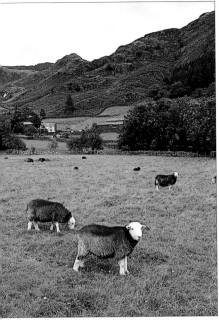

## Technical tips

• If you need the foreground sharp, use the lens's depth of field scale to select the right aperture and focus distance.

• Unwanted foreground can be cut by using the panorama mask found on some SLRs – or by cropping the print.

### ◀ Diminishing size
*Livestock can provide the perfect accompaniment to a landscape shot. An added benefit of the cows in this shot is that, although we know they are roughly the same size, the ones further away appear smaller. This helps to add a feeling of depth to the photograph.*

### ▲ Frames within frames
*A balcony forms a natural window through which to look at the mountain and lake beyond.*

### ▶ Foreground patterns
*These rusty pieces of metals form an interesting mosaic in the foreground of this shot of a port. Piles of wood and stones can also prove useful foreground fillers for the landscape photographer.*

# Unusual viewpoints

Try to avoid shooting every shot you take standing straight-on to the subject, with your camera at normal eye level. Shoot a series of pictures which give bird's-eye and worm's-eye views – looking down or up at your subject. Experiment by kneeling down low, or even lying on your back to get an interesting vantage point. Look for ways to climb above subjects. Doing this will force you to hunt out interesting and unusual camera angles. Such shots can yield dramatic angles and unusual perspectives, and help to create mood and atmosphere.

**◄ Eye to the sky**
*To take this unusual view of a spiral staircase in an Austrian monastery, I laid the camera on the floor. Lying on its back, the camera was fitted with a 15mm lens to fill the frame with the shell-like curves of this extraordinary piece of architecture.*

## High vantage points

*A bridge allowed me an interesting view of this floating lady. The high viewpoint has allowed the shape of the raft and the parasol to stand out against the blue tones of the water.*

### ▲ Worm's-eye view
*Looking straight up at tall subjects helps to show their size and the way they dominate the skyline. Here, trees make an interesting pattern.*

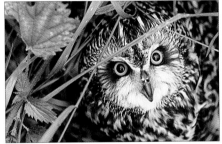

### ▲ Bird's-eye view
*Standing above a living subject stresses its vulnerability, small size and inferiority. Use the technique with human subjects with care!*

## Technical tips

• Looking upwards with the camera makes vertical lines seem to converge. This feature of perspective can be overused when shooting buildings.

• When shooting children, kneel down and shoot from below their eyeline to make them look more self-assured.

# Maximizing depth

It is tempting to shoot static subjects, such as architecture, interiors, landscapes and still lifes, with a handheld camera, but this restricts the aperture you can use.

With many of these subjects, useful extra depth of field can be achieved by using a tripod and a slow shutter speed in order to use the smallest apertures your lens has to offer.

**◄ Close-up definition**

*The closer you get to a subject, the smaller the depth of field becomes. It is not uncommon when using a macro lens for depth of field to stretch only a couple of millimetres in front of and behind the point of focus – even when using small apertures. In this shot, I used an aperture of f/22 and focused on the face of the doll to ensure it was sharp.*

**► Interior solutions**

*There are two common problems when shooting interiors – the light is low, and you need to keep objects a few centimetres away from the camera as sharp as those several metres away. A small aperture is not possible when hand-holding the camera. For this shot of a hotel, I used a tripod, which allowed me to use a shutter speed of one second to get the aperture of f/32 to ensure everything was sharp.*

## Technical tips

• Use depth of field scales and depth of field preview to find out how much of the scene will be sharp (see p. 31).

• Use a solid tripod and a slow shutter speed when necessary to get the most suitable aperture for your shot.

### ◀ Focus a third of the way in
*Focusing on a point one-third of the way between you and the horizon will maximize depth for a given aperture.*

### ▼ Sharp focus throughout
*In this shot, the background and foreground are as interesting as the still life itself. By ensuring these are sharp, the texture of the wood can be seen clearly.*

# Tricks of perspective

Wideangle and telephoto lenses can be used to produce unusual views of the world – simply through their affect on perspective. Wideangle lenses allow you to shoot closer to a subject than telephotos, and this difference in subject distance affects the relative scale of foreground objects to background ones.

Wideangle lenses make the foreground look bigger than we usually see it, and the background smaller. Telephotos, however, with their selective view, make distant objects look closer to each other than they really are, as their scale changes only slightly. This makes the background appear larger than usual.

**◀ Parallel lines**

*In this classic illustration of linear perspective, the use of a 35mm wideangle lens has made the railway tracks appear to converge steeply towards each other. The wider the lens, the more dramatic the effect will be. If we used a telephoto lens, the foreground in the shot would have been further away and the lines would have appeared more parallel.*

## Technical tips

• Perspective changes with subject distance, not with the focal length used (see pp. 32–33).

• Change the shooting distance and focal length to affect the dominance, and recognizability, of the background.

## ▲ Using the foreground

To exaggerate changes of scale using a wideangle, you need to have recognizable objects right in the foreground of the picture. Here it is the boy's shoe, which looks monster-sized through a 28mm lens.

## ▼ Reducing depth

A telephoto lens can be used to suppress form and depth in a picture. This shot, taken with a 300mm lens, makes the fields and tractor look as if they are practically on top of each other.

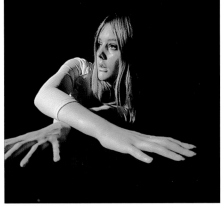

## ▲ Distorted figures

Here the model has posed with her hands just inches away from the lens, whilst her face is a couple of feet away. The difference in subject distances, seen through a 20mm lens, produces a surprising, even disturbing, view of the human body.

# Fleeting light

**C**loudy weather is often the best time to go out with your camera – particularly with landscapes. It is the sudden breaks in the cloud, allowing the sunlight to stream through and spotlight just part of the scene, that make this weather so interesting. The areas of light and dark constantly change as the clouds move across the sky, so you may have to wait for the effect you want, and then act fast before conditions alter.

▶ **Patterns of shade and light**
*With portraits, unlike landscapes, you can often move your subject to the light you require. Here the model lay down in a triangular pool of light.*

## Bring the sun indoors

Fleeting light can transform interiors as well as landscapes, a brief ray of sun adding much-needed contrast, colour and form to the room.

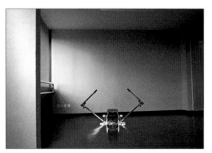

▲ **Overcast sky**
*The soft, indirect daylight does little for this scene. The lack of shadows makes the room look lifeless, and the dull colours do not make things stand out.*

▲ **Streaming sunlight**
*A moment later, as the sun breaks through, the scene is transformed. Not only are colours improved, but the shadows of the blinds make the shot.*

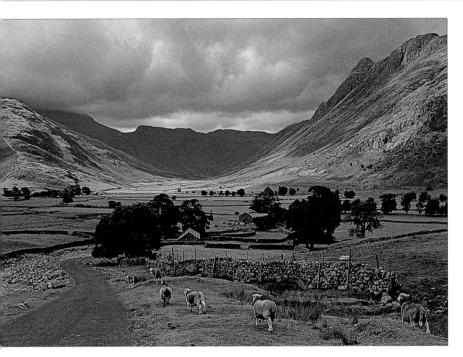

### ▲ After the storm
*Dark clouds help to make some of the most dramatic landscape shots. The best pictures are often taken just after the rain, as the sun peeks through the heavy cloud, creating a high contrast between frontal lighting and the black sky behind.*

### ◄ The waiting game
*Everything comes to those that wait – I spent 20 minutes for these trees to be spotlit by the sun through the passing clouds.*

## Technical tips

• A polarizing filter can help to intensify the colour of a cloudy sky. Remember to rotate it for maximum effect.

• Listen to local weather forecasts.

# Changing light

The time of day has a tremendous impact on how a scene appears. Not only does the direction of lighting change gradually from dawn to dusk, but the ever-changing pattern of the clouds means that subjects that are in direct sunlight one moment, are softly lit the next. The colour of light also changes, from the deep red of a sunset to the bright blue reflected by the sun on a summer's day. The human eye compensates for these subtle changes in colour – but photographic film can not.

▶ **8am**

*Early morning, and a brief break in the clouds creates a spotlight on the white chimneys of London's famous Battersea power station. The rest of the river scene, however, is bathed in softer light, diffused by the clouds above.*

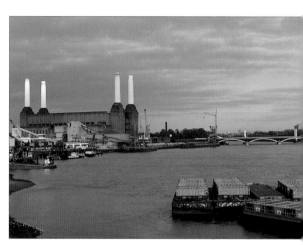

◀ **9am**

*An hour later, and much of the scene is now lit by direct light. With the sun almost behind me there is only a slight line of shadow down the sides of the chimneys – but it is just enough to suggest their cylindrical form. The frontal lighting, however, means that there is a pleasant reflection of the power station in the water.*

### 11am

Two hours further into the morning, and the scene has changed subtly yet again. The fluffy clouds now make an interesting backdrop to the urban landscape, and I switched to a wider lens setting to include more of the sky in the shot. The scene is now lit by semi-diffused sunlight. Notice that the modelling on the chimneys is more pronounced than in the previous shot in the sequence.

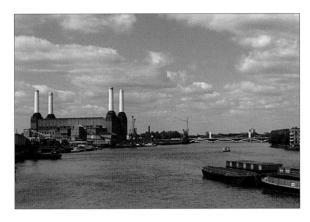

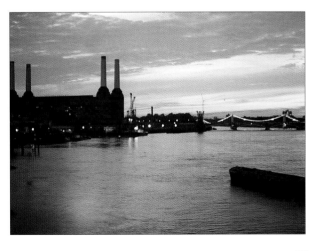

### ◀ 6pm

Early evening, and the setting sun not only changes the colour of the sky, but turns the chimneys and other structures into dark silhouettes. The backlighting creates a simplified, monotone landscape.

### ▼ 8pm

Later in the evening, but it is not yet completely dark - leaving some colour of the sunset in the sky. As the lights of London are now turned on, we have a far more detailed and colourful scene than the one taken two hours earlier.

## Technical tips

• Shoot landscapes in early morning, rather than at midday, as the light is normally better.

• Slide film may require a skylight, or warm-up, filter in strong sunlight.

• Be prepared to wait for the light to be right.

# Special effects

Photography has a complex series of rules, designed to get you the best pictures in a variety of situations. But all can be broken.

Keeping the camera still during the exposure, for instance, is important if you want to avoid camera shake (see p. 16). But with action shots, if you pan your camera to follow the subject, you can end up with more evocative pictures. Similarly, most cameras are designed so you can't accidentally shoot more than one picture on each frame. But sometimes this 'mistake' can produce interesting results.

Never be afraid to break the rules. Experimentation helps you learn and is how new techniques are found out

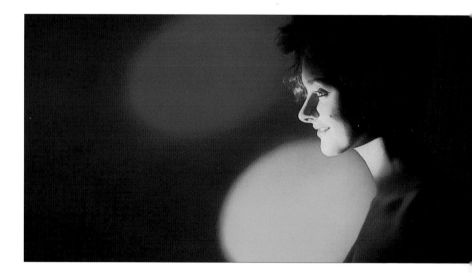

**▲ Coloured flash**
*Usually we choose film and lighting to make skin tones look as natural as possible. In this colourful portrait, however, I put a gel (a large filter) on the flash to turn the model's face yellow. Green and red gels were put on the background spotlights.*

**▶ Zooming during exposure**
*This technique involves using a zoom and a slow shutter speed and zooming whilst taking the shot. It lends an explosive quality to action subjects. I used a 35–80mm lens with a ⅛ sec exposure.*

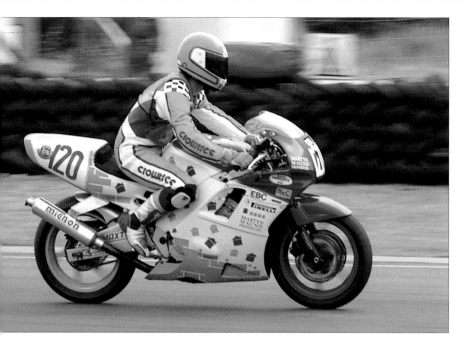

### ▲ Panning with the action
*This trick involves following a moving subject with the camera as you shoot the picture. The blurred background provides a feeling of movement. Here I used a 200mm lens and a ¹/₂₅₀ sec exposure.*

### ◄ Multiple flash
*As the model moved across the frame of a dark studio, I fired the flash repeatedly, to produce a sequence of exposures on one frame.*

## Technical tips

• To pan, use a shutter speed that is four times longer than that necessary to freeze the action (see pp. 20–21).

• Zoom bursts work best with brightly coloured subjects.

# Flash effects

The short, intense burst of light from a flashgun can be useful in many situations. The way in which it works with different kinds of ambient light can change the whole mood of a picture. In daylight, flash can increase or decrease contrast – adding form and colour on a dull day, or avoiding silhouettes in backlit situations. As the flash burst can be as short as $\frac{1}{40,000}$ sec, it can provide action-stopping shutter speeds that are otherwise impossible. Several flashes can be used in one shot, allowing you to light large areas evenly or allowing the use of much smaller apertures.

▲ **Slow-synch flash**
*Flash can be used effectively to convey movement in good and poor light. Instead of using the normal flash synchronization setting, set a slower shutter speed (I used ⅛ sec here). The brief burst of flash freezes the action, whilst the ambient light creates a ghostly after-image which suggests the movement of the subject. The technique only works well with subjects close to the camera.*

## Technical tips

• The more powerful the flashgun, the more choice you have over aperture.

• The top shutter speed you can use with flash varies from SLR to SLR.

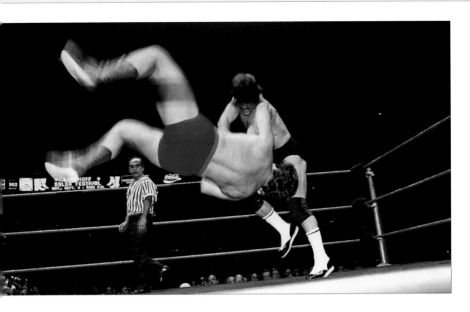

## ▲ Freezing the movement

*Although I used a shutter speed of 1/60 sec for this shot, the wrestlers are caught sharply in mid-air because of the very brief duration of the flash. This lasted for around 1/2000 sec. As the flash is only effective over a few metres, the distant background remains dark, highlighting the action.*

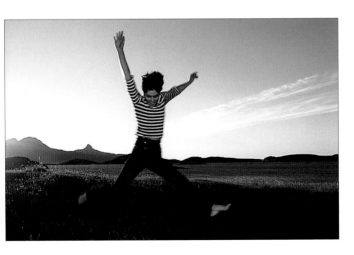

## ◄ Filling in

*Fill-in flash is one of the most useful techniques to master. By using a flashgun in daylight here, I have been able to include the setting sun in the frame without the model turning into a silhouette. Many SLRs can set the aperture and shutter speed for this type of shot automatically.*

# Creative blur

Sport is not the only type of action subject. Nearly every scene has some movement in it, whether it be people, scudding clouds or trees swaying in the wind. By using a slower shutter speed than usual you can convey this effect, as moving elements will become a blur. Choosing how much blur to use is not easy. Too little, and it might look like a mistake. Too much, and your subject may become completely unrecognizable.

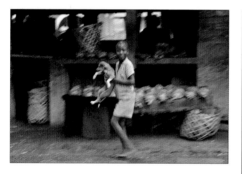

▲ **Minor movement**
*To capture this boy carrying his dog, I used a shutter speed of ¹⁄₁₅ sec handheld with a 100mm lens. This created just a small amount of blur.*

## Technical tips

• If possible, use a variety of shutter speeds to vary the amount of blur.

• Use a shutter speed that is at least two stops slower than the one that you would use to freeze the subject (see speed table on p. 20).

• Accurate picture composition is difficult, so shoot a lot of film.

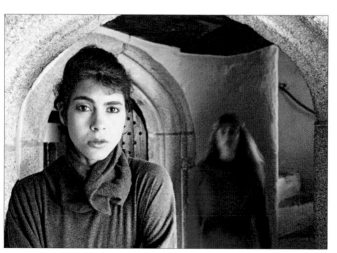

◄ **Selective blurring**
*In this shot only the woman in red, in the background, is blurred. The woman in the foreground stood still as I used a shutter speed of ¹⁄₈ sec, with the camera on a tripod. The woman in red walked towards the camera as the exposure was taken.*

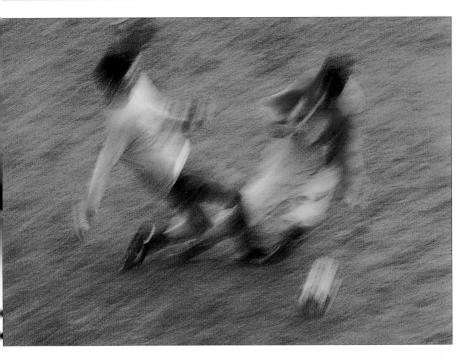

### ▲ Impressions of sport

A slow shutter speed helps give sport an impressionistic feel. You need to pick your camera angle and moment well so that the viewer can still see what is going on. I took this shot of a local French football match using a shutter speed of ¹⁄₁₅ sec and a 200mm lens on a monopod.

### ▶ Moving space

When composing subjects moving across the frame, leave space in front of the subject for a more comfortable shot. This cyclist was shot with a shutter speed of ¹⁄₃₀ sec.

# Out-of-focus backgrounds

It is often helpful to simplify a photograph – if there is too much detail, it can be hard to spot the main subject and the frame can look cluttered. The simplest way to emphasize your subject, and suppress unwanted detail, is by controlling depth of field (see p. 28). Often it is a background that needs to be thrown out of focus so that it becomes an abstract design, rather than a distraction. As well as using a large aperture to restrict how much is in focus, remember that you can also get closer to the subject or use a longer lens to limit depth of field.

**◀ Making it stand out**
*The thin latticework of this spider's web does not naturally stand out well from its background. Fortunately for the photographer, the closer you get to your subject, the more limited the amount of depth of field becomes. With macro lenses you will find that the distance between the closest and farthest points that are in focus is often just a few millimetres. Note that with macro subjects, depth of field is evenly distributed in front of and behind the point of focus.*

**◀ Selective emphasis**
*The eyes of the viewer are drawn immediately to the woman in the foreground, as the rest of the group are slightly out of focus. The composition is too complex to have everything sharp at the same time, so f/4 – the largest aperture available on my 35mm lens – was selected to keep depth of field in check.*

**▶ Anonymous backgrounds**
*This candid portrait has been shot so that the backdrop is as out of focus as possible. A telephoto lens setting which restricts the amount of background in view, combined with a wide aperture of f/2.8, have helped to achieve this.*

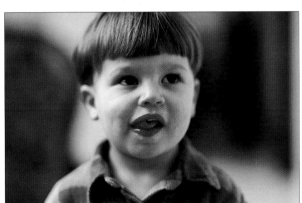

## Technical tips

• The amount of depth of field is dependent on three major factors: the focal length of lens used, the aperture, and the focused distance (see p. 28).

• To reduce depth of field use a longer lens, select a larger aperture, or get closer to your subject. Often you will have to combine all three to get the effect you require.

• The degree to which a background is out of focus varies. Even if it is blurred, it can still be recognizable or distracting.

# Expressive portraits

Sad, happy, old, young, tired, shocked, thoughtful – faces tell you much about a person, even if you do not know them personally.

The head-and-shoulder portrait allows you to concentrate on facial expressions whether they are spontaneous or posed.

When shooting any portrait, it is usual to avoid composing the shot so that the bottom of the picture cuts through the neck, elbows, waist or knees. Close-up shots should include some of the shoulders. Generally, a gap should be left between the top of the frame and the top of the head.

▶ **Vertical framing**
*The 35mm film format is not ideally suited to close-up portraits – it is too rectangular – but upright compositions can sometimes work. Here, the vertical format emphasizes the natural frame around this old woman's face, made by her black scarf and dress. Horizontal framing, however, works well on most occasions, without the need for cropping.*

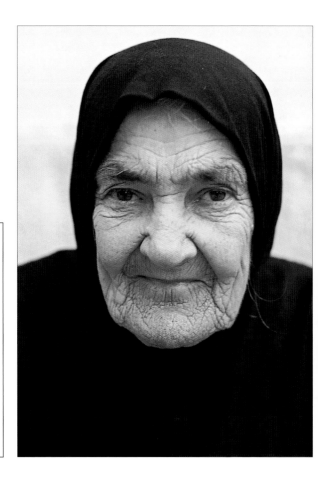

## Technical tips

• Use a medium telephoto lens setting – 100mm is ideal.

• Focus on the eyes to ensure that they are sharp.

• Avoid using harsh, direct sunlight.

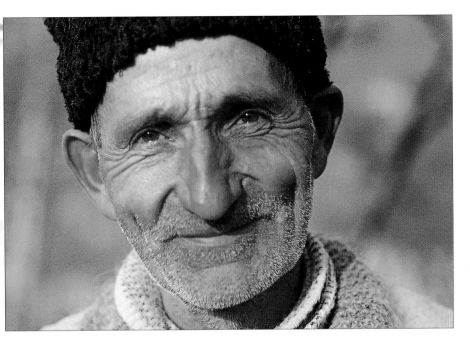

### ▲ Focal points
When viewing a portrait, we are first drawn to the eyes of the subject. When using a wide aperture, it is essential to focus on the eyes.

### ▲ Playing the part
A smiling subject would look wrong for this shot of a man dressed as a Viking. A mean, unemotional stare, however, complements his costume.

### ▶ Grab the moment
Dramatic facial expressions are fleeting by nature; you must be prepared if you want to catch them.

# Posing people

Whatever the subject, there are always hundreds of ways to capture it on film. When shooting portraits, not only can you change camera position, lighting and lens, you can also alter the way the subject looks. By getting your sitter to vary the pose, you can get an almost infinite variety to your shots without even moving!

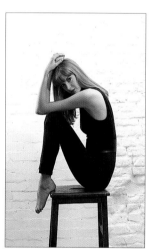
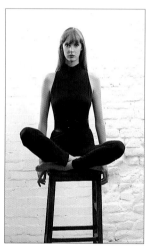
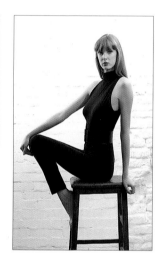
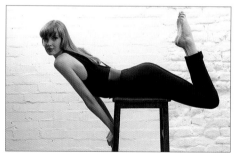
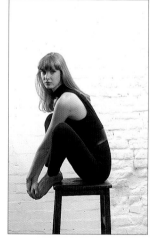

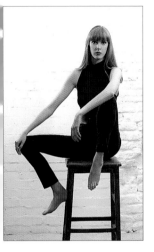
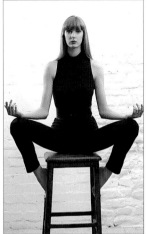
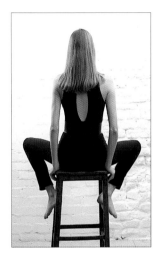
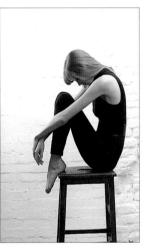
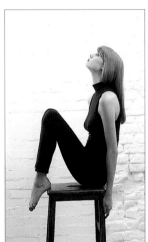
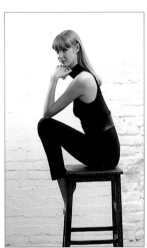

### ◄▲ Covering all the angles

*In this exercise, I deliberately set out to show how many different poses were possible with a single model and a bar stool. The simple white background of the wall was chosen as it perfectly complemented the girl's striking black outfit. Notice how even small changes to the position of the arms and legs can have an effect on the picture.*

## Technical tips

• Get everything set up and ready before the model arrives.

• Keep background, props, clothes and lighting as simple as possible.

# At work & play

Although it is tempting to compose portraits so that the face fills the whole frame, the setting and the objects surrounding the sitter can often tell us a lot about a person's lifestyle or profession.

The background or setting that you choose should complement the subject, rather than detract from it. Careful use of props, too, whether an artisan's tool or a child's toy, can add interest and information to a shot.

**▲ Foreground colour**
*The black and white clothes may give away the occupation of this waitress, but they look drab on film. But with a tray of colourful cakes in her hand, the shot comes alive. With a neutral background, the eye is drawn diagonally from the circular tray in the foreground to the face.*

**▶ Context**
*The out-of-focus wire mesh in the foreground not only helps frame the subject, but its connotation of security complements his profession.*

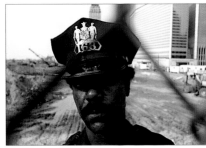

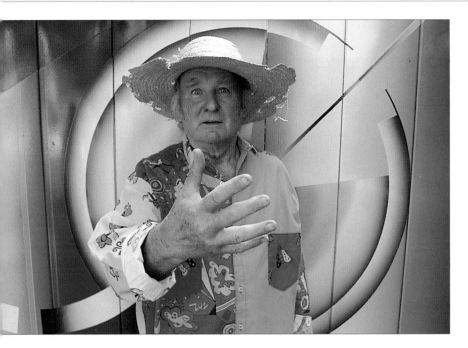

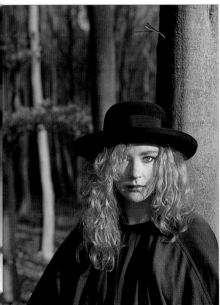

### ▲ A suitable setting

*I was struck by the similarity between the colours of this artist's shirt and those he used in his abstract paintings, so I used one as the background of this portrait.*

### ◀ Matching colours

*The autumnal hues of this wood make a perfect backdrop for this portrait, with the coppery leaves toning perfectly with the girl's flowing red hair.*

## Technical tips

• Keep the composition simple — avoid cluttered backgrounds and don't use too many props.

• If you have difficulty finding a suitable backdrop, it may be easier to ask the subject to change their clothes.

# Thinking in black & white

As there is no colour, black and white photography relies far more on form, texture, shape and pattern than other pictures. Also, as we do not see in monochrome, it can be a harder medium to work with. Colour must still be taken into account, as the weight of specific colours is not the same on black and white film as it appears to the eye. Red and blue appears lighter, whilst green becomes darker. Grass and skies may need filters to restore a natural tonal balance (see p. 43).

**◀ Simplifying shapes**
*Without the distraction of colour, monochrome pictures use tone alone to suggest lighting. In this shot, the shapes of the leaves in the foreground stand out against the lighter shades of foliage in the background.*

**▼ Monochrome moods**
*In landscape and portrait photography, black and white film has a reputation for producing moody images. By emphasizing both light and shade, either through camera or darkroom technique, you can produce prints which exaggerate contrast.*

## Technical tips

• Accurate exposure is essential to achieve a full range of tones.

• Learn to develop your own prints – black and white images can be manipulated in the darkroom.

### ▲ Grainy effect
High-speed black and white films can be processed and printed to exaggerate the grain of the film. This can add a gritty dimension to your photographs which can work well with landscapes and portraits, like this photograph of David Hockney in his studio (above). Indoors, black and white film can be particularly useful, as it neatly sidesteps any problems with colour casts caused by a mixture of light sources.

### ◀ Classic portraiture
Black and white is a very effective medium for portraiture. Coloured clothes and backgrounds are less distracting when shown in monochrome, focusing attention on the model. In this shot, the tones of the cut branches provide a complementary background to the gardener.

# Glossary

**Aperture** Variable lens opening which restricts how much light reaches the film.

**Aperture priority** Exposure mode where the aperture is set by the user and the shutter speed is set automatically.

**Barrel distortion** Common defect on wideangle lenses, causing straight lines at the edge of the picture to curve outwards.

**Bracketing** Technique for ensuring correct exposure where several photographs of the same scene are taken at slightly different exposure settings.

**B setting** Special setting for long exposures. The shutter is kept open for as long as the trigger is pressed down.

**Colour temperature** Measure of the relative blueness or redness of light.

**Depth of field** The range of distances that look acceptably sharp within a shot.

**DX coding** System where the film speed can be set automatically by the SLR using a silvered pattern on the film canister.

**Extension tubes** Accessories used in close-up photography, fitting between the lens and SLR body.

**f/number** A measure of the size of the aperture. The number refers to the focal length of the lens divided by the diameter of the aperture opening.

**Guide number** Measure of the power of a flash gun. For a given film speed, the guide number is divided by the subject distance to give the aperture needed.

**Inverse square law** Rule stating that the intensity of light decreases with the square of the distance from its source.

**ISO** A measure of a film's sensitivity to light, as laid down by the International Standards Organization.

**Latitude** The tolerance of a film to variations in exposure.

**Pentaprism** Prism used in SLR viewfinders that ensures the image seen is the right way round and right way up.

**Program exposure** Exposure mode on SLRs where both aperture and shutter speed are set automatically.

**Reversing ring** Accessory for close-up photography, allowing a lens to be mounted back-to-front on a SLR.

**Shutter priority** Exposure mode where shutter speed is set by the user and the aperture is set automatically by the SLR.

**Stop** Alternative name for aperture setting or f/number.

**Synch speed** The fastest shutter speed when using flash for a particular SLR.

**Zoom** Lens with a variable focal length.

# Index

# Acknowledgements

The Publishers would like to thank Chris George for all his hard work and advice in helping to create this book, and Amzie Viladout for his design. Also, many thanks to David Ashby for providing the illustrations and to Corinne Asghar, Dawn Butcher and Ian Kearey for their help.

The Author would like to extend his thanks to the following organisations for their cooperation: Aylsham Boxing Club, Durham Cathedral, English Heritage, the gardens of Drummond Castle and Oxnead Hall, Greenwich Naval College, Snetterton Race Circuit, and the tourist offices of Austria, Gambia, Isle of Man, Italy, Jersey, and Romania. Also many thanks to all the models.

The majority of the photographs were taken with a Pentax camera.

**Photographic credits**
The following photographs were reproduced with kind permission: page 8 – camera (Nikon); page 12 – camera (Canon); page 18 – tripod (Velbon).